THOMAS LAWRENCE

Coming of Age
1780–1794

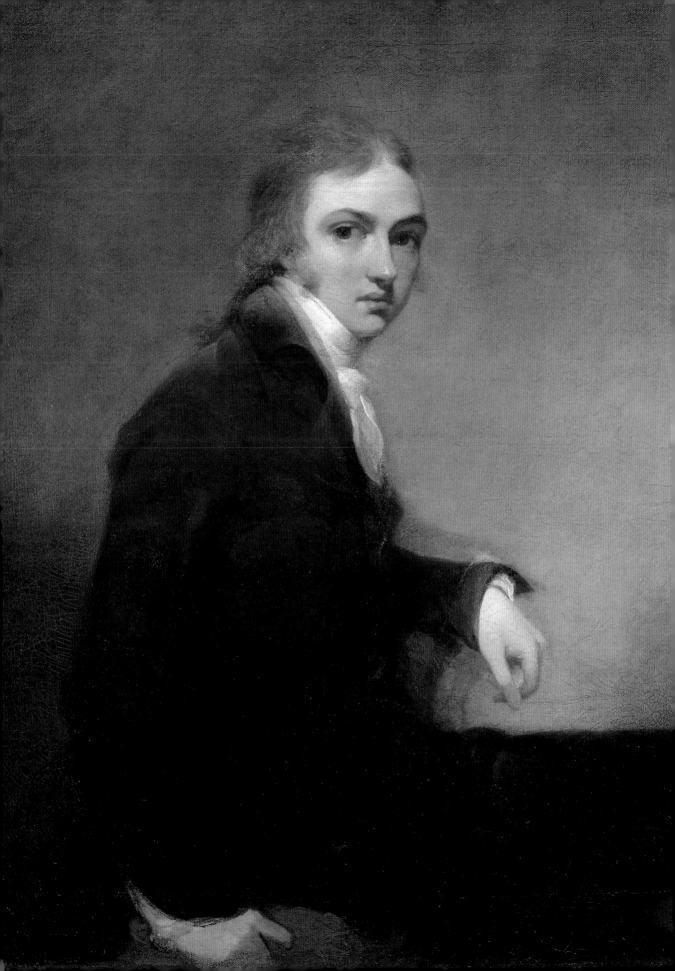

THOMAS LAWRENCE

Coming of Age
1780–1794

Amina Wright

PWP THE HOLBURNE MUSEUM

PHILIP WILSON PUBLISHERS
Bloomsbury Publishing Plc
50 Bedford Square, London, WC1B 3DP, UK
1385 Broadway, 5th Floor, New York, NY 10018

BLOOMSBURY, PHILIP WILSON PUBLISHERS and the Philip Wilson logo are
trademarks of Bloomsbury Publishing Plc

First published in Great Britain in 2020

Published on the occasion of the 2021 exhibition:
Thomas Lawrence: Coming of Age (1780–1794)
The Holburne Museum, Bath

A catalogue record for this book is available from the British Library.
Library of Congress Cataloguing-in-Publication data has been applied for.

ISBN: 978-1-78130-094-7

10 9 8 7 6 5 4 3 2 1

Designed by Caroline and Roger Hillier, The Old Chapel Graphic Design
www.theoldchapellivinghoe.com
Printed and bound in China by RR Donnelly Asia Printing Solutions

Bloomsbury Publishing Plc makes every effort to ensure that the papers used in
the manufacture of our books are natural, recyclable products made from wood
grown in well-managed forests. Our manufacturing processes conform to the
environmental regulations of the country of origin.

To find out more about our authors and books visit www.bloomsbury.com and sign
up for our newsletters.

This exhibition has been made possible as a result of the Government Indemnity
Scheme. The Holburne Museum would like to thank HM Government for providing
indemnity and the Department for Digital, Culture, Media and Sport and Arts
Council England for arranging the indemnity.

Frontispiece: *Self-Portrait, c.*1787 (detail of Fig. 20)

Contents

Author's Acknowledgements

Thomas Lawrence's portraits are associated with glamour, beauty, luxury and power, but the turbulence of the age that created them is scarcely concealed under their glittering surface. His aim as an artist was not only to convey the opulent textures and colours of costumed figures but, as he confided to his Bath neighbour Mary Hartley, 'expressing with truth the human heart in the traits of the countenance'. The unfinished portrait of Arthur Atherley, acquired by the Holburne Museum in 2016, has drawn this aspect of Lawrence's work to the attention of a new audience – thanks to the acquisition funding for *Arthur Atherley* from the National Lottery Heritage Fund, which enabled the Holburne to run an innovative community engagement and outreach project: A New Portrait for Bath. By introducing the portrait to schools, colleges and care homes, Arthur Atherley came to embody the universal experience of growing up and all the fear, hope, vulnerability and excitement that comes with it. The project also generated curiosity about the young Lawrence's artistic and personal journey from rural Wiltshire to the highest echelons of London society, via Bath and its creative industries. It was this enthusiasm to celebrate Lawrence as a local hero that has given rise to this book and the exhibition it accompanies.

Assembling a loan exhibition inevitably involves studying a large number of works of art, and I am grateful to all those who have allowed me access to their collections and archives: Antony Alderson; Nicholas Bagshawe; Hugh Belsey; Patrick and Cordelia Bourne; Chris Coles at the British Museum; Clementine Sinclair at Christie's; Rachel Sloane at the Courtauld Institute; Alice Carr-Archer at Dulwich Picture Gallery; Ben and Rachel Elwes; Amy Marquis and Henrietta Ward at the Fitzwilliam Museum; Susan Colletta and Melinda McCurdy at the Huntington; Leah Lehmbeck at the Los Angeles County Museum of Art; James Mitchell; Anthony Mould; Susan Foister and Mary Hersov at the National Gallery; Anne Pritchard and Carolyn Charles at the National Museum Wales; Rab McGibbon at the National Portrait Gallery; Lawrence Hendra at Philip Mould & Co; Annette Wickham, Mark Pomeroy and Daniel Bowmar at the Royal Academy of Arts; Peter Cannon-Brookes and Gill Dent at Tabley House; Emily Knight at the Victoria & Albert Museum; the staff of the Victoria Art Gallery; and Dominique Shembry at The Vyne.

Over the years, successive Holburne directors Christopher Woodward, Alexander Sturgis, Jennifer Scott and Chris Stephens have encouraged me to pursue my research on Lawrence's early work and I am grateful to them for recognising the value of Lawrence's legacy for Bath today. Warmest thanks to the team at the Holburne for all their help during this project, particularly Laura Bridges, Sylvie Broussine, Nina Harrison Leins, Katie Jenkins, Camilla Johns, Christina Parker and Bethany Pleydell, and to volunteers Undine Concannon and Caroline Ames.

Special thanks are due to Mark Hallett and Sarah Turner at the Paul Mellon Centre for Studies in British Art for facilitating a preliminary discussion of content and themes for the exhibition and book, and to Sarah Monks, Michael Rowe, Susan Sloman, David Solkin and Joanne Whitmore for their contributions and expertise on the day. Among the many others who have offered advice and encouragement are Brian Allen, James Baxendale, Philippa Bishop, Peter Funnell, Neil Jeffares, Lowell Libson, Stephen Lloyd, Martin Myrone, Martin Postle, David Taylor, Katharine Wall and Jonny Yarker and, in Paris, Sophie Eloy, Jérôme Farigoule and Frédéric Ogée.

This book would not have been possible without funding from the Pilgrim Trust, Paul Mellon Centre for Studies in British Art, and Ben Elwes Fine Art. Much of the travel within England, Wales and California was enabled by a Jonathan Ruffer Curatorial Research Grant from the Art Fund.

In writing *Coming of Age*, I have been unable to surpass the comprehensive and sympathetic opening chapters of Michael Levey's biographical survey of 2005 or the further insights on Lawrence as an artist provided by the publication for the 2010 exhibition *Regency Power and Brilliance*. Kenneth Garlick's catalogues have been a crucial point of reference, as has his unpublished archive in the Heinz Archive at the National Portrait Gallery. Neil Jeffares and his exhaustive *Dictionary of Pastellists* have been an essential source of facts and advice for the Bath period. I am especially indebted to Susan Sloman for her generous sharing of files, books and her encyclopaedic knowledge of eighteenth-century Bath artists, and to Lucy Peltz at the National Portrait Gallery for her encouragement and enthusiasm over the many years' gestation of this project.

Foreword

If a film was made of Thomas Lawrence's rise to fame and fortune it would be written off as a hackneyed cliché. Who, I wonder, would play the prodigiously talented young man who is spotted by the rich and celebrated when they stopped off at his father's inn in Devizes on their way to the fashionable spa town of Bath? At the age of eleven, Lawrence himself moved with his parents to Bath. There he was soon making a living, drawing portraits in pencil and, later, in pastels. His sitters included some of the most famous and glamorous of British high society, including Georgiana, Duchess of Devonshire and the great actress Sarah Siddons. At age eighteen, Lawrence moved to London where he took up oil painting and would soon be celebrated as the heir to Sir Joshua Reynolds, the founding president of the Royal Academy. He, himself, exhibited at the Academy from 1787 and, in 1789, he was commissioned to paint Queen Charlotte, the wife of the ailing George III and mother of the Prince Regent. By 1792, he had been appointed official painter to the king and, two years later, was elected a Royal Academician.

This book and the exhibition it accompanies were originally prompted by the acquisition by the Holburne Museum, Bath, of an unfinished version of one of Lawrence's greatest works, his *Portrait of Arthur Atherley as an Etonian*, 1791-2. The finished painting, now in the Los Angeles County Museum of Art, was commissioned on the occasion of the subject's leaving Eton College. It is one of a number of portraits by Lawrence of young men, and women, in their late teens, on the cusp of adulthood. This is, perhaps, a unique phenomenon of an artist portraying young adulthood when he was, himself, not much older than the sitters. It is around this idea of young people facing a rite of passage, confronting the hopes and fears of leaving adolescence for adulthood, that we find some

of the contemporary resonances in Lawrence's art. It was in relation to that issue that some of the Holburne's community engagement work was focused following the acquisition of our *Arthur Atherley*.

I am very grateful to Amina Wright, formerly Senior Curator at the Holburne, for continuing her work on Lawrence with the curating of the 2021 exhibition and the writing of this book. Her commitment to Lawrence, to our work around the Atherley portrait and her deep knowledge of the art of eighteenth-century Bath uniquely equipped her for this project and I am pleased to thank her for the intelligence and sensitivity she has brought to both exhibition and book. I should also thank my predecessor as Director of the Holburne, Jennifer Scott, for the acquisition of *Arthur* and for programming the exhibition. The publication and other aspects of the project have been generously supported with a Jonathan Ruffer grant from the Art Fund, and by the Paul Mellon Centre for Studies in British Art, the Pilgrim Trust and Ben Elwes Fine Art. I am hugely grateful to Mark Hallett, Martin Postle and Sarah Turner at the Paul Mellon Centre and to Rachel and Ben Elwes for their support and understanding beyond simply the provision of vital subsidy to make this book possible. As ever, the team at the Holburne have all in different ways helped deliver the project but I am especially grateful to Sylvie Broussine for assisting Amina and to Nina Harrison Leins for expertly navigating the exhibition and book through any tricky waters. Finally, I would add my thanks to Amina's to all those lenders, advisors and colleagues who have helped realise this exciting book and exhibition.

Chris Stephens, Director of the Holburne Museum

Introduction

On 7 April 1780, Frances Burney, celebrated author of *Evelina* (1778), arrived in Bath with her friend Hester Thrale. Breaking their journey at the Black Bear inn at Devizes, the ladies had been 'much pleased with our Hostess, Mrs Lawrence, who seemed something above her station in her Inn', and her youngest son, 'a most lovely Boy of 10 years of Age, who seems to be not merely the wonder of their Family, but of the Times for his astonishing skill in Drawing. They protest he has never had any instruction. [...] I was equally struck with the Boy as his works, – he has [...] such sweet, expressive, soft, intelligent Eyes.'[1]

The exceptional skill and winsome looks that charmed Burney (1752–1840) can be glimpsed in a miniature drawing which, according to a later inscription, was made by Thomas Lawrence (1769–1830) 'at 12 years of age / 1781' (fig. 1). Lawrence has constructed a formal and self-conscious image of himself as both artist and child. His long curling hair recalls the young courtiers of Anthony van Dyck; the soft open collar and scarf draped over the shoulders give his costume an archaic air with a suggestion of the dressing-up box, as though the boy is playing the part of an artist.

One of the most curious features of this little drawing is its use of vellum, which by this time was rarely employed as a support for drawings. It gives the effect of a much older work, echoing the silverpoint studies of Old Masters. To modern viewers, Lawrence's work may recall the silverpoint self-portrait (1484) made by Albrecht Dürer at the age of twelve or thirteen, or Parmigianino's *Self-Portrait in a Convex Mirror* (1523/24), both ambitious celebrations of youthful genius.[2] In his own time Lawrence was compared to the Renaissance master Raphael, not only for his skill but also for his appearance, which recalled the Old Master's portraits of himself and other young men.[3] Although the drawing has borrowed the language of sentimental decorative prints to portray an idealised boy with large eyes and delicate features, a comparison with other portraits of Lawrence shows that this is not an inaccurate likeness.

Within six months of Burney's visit to Devizes, the Lawrences had left the Black Bear and were living in Bath; the local press announced the arrival of the boy wonder and his 'Striking Sketches', inviting the 'Nobility and Gentry' to sit for their portraits.[4] Lawrence, later President of the Royal Academy, was to become one of the most famous and gifted artists to have worked in Bath, second only to Thomas Gainsborough (1727–1788). The six years he lived in Bath coincided with his adolescence and, during this time, his development as a professional artist and a public figure was extraordinarily rapid, even for an era when working life necessarily began much earlier than it does today. By the time he came of age in 1790, Lawrence was one of the most exciting figures in the London art world, where his glamorous, original and ambitious portraits of celebrities and royalty were met with disbelief.

This book follows Lawrence's journey from the age of ten to twenty-five, from his Wiltshire childhood to membership of the Royal Academy in London and from pocket-sized pencil drawings to colossal oil paintings. It tells the story of an artist growing up and considers his depictions of fellow travellers on the sometimes dangerous journey from childhood to maturity.

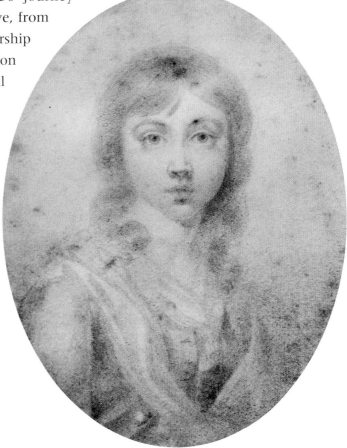

Fig. 1
Self-Portrait Aged Twelve
1781
Graphite on vellum
10.5 × 8 cm
Victoria Art Gallery,
Bath and North East
Somerset Council

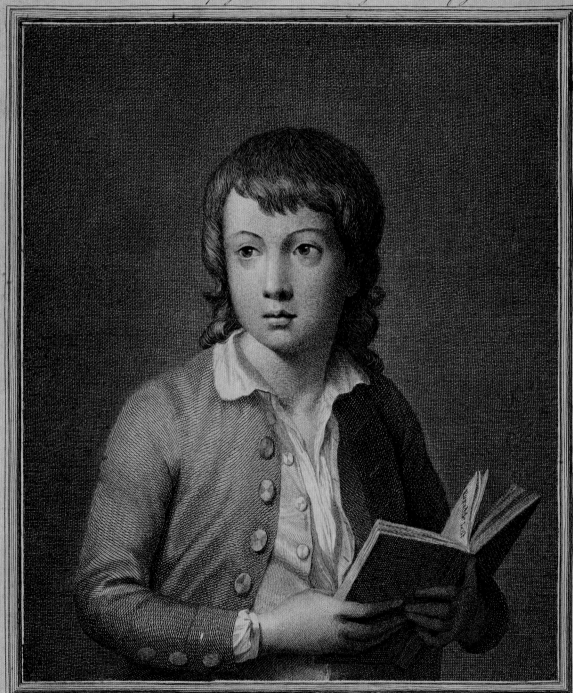

The Engraving directed by I.R. Sherwin

To the NOBILITY & GENTRY in general, & the UNIVERSITY of OXFORD in particular, who have so liberally
countenanced his pencil, this portrait of Master Lawrence, is Inscribed, by their most devoted & most grateful Serv.t
T. Lawrence, Sen.r

Published June a. 1783. by T. Lawrence, Alfred Street, Bath, & a print of M.rs Siddons, in the Character of Zara, Drawn by Master Lawrence, & Engraved by I. R. Smith.

Portrait of the Artist as a Young Prodigy

At the Black Bear, Fanny Burney was most intrigued to find a family running a Wiltshire coaching inn who, in their interest in books, art and music were not unlike her own, the talented and well-connected Burneys. But the Black Bear was a superior establishment whose cultivated and influential patrons helped lay the foundations of Lawrence's future success; his father was no ordinary provincial innkeeper.

Thomas Lawrence senior was a colourful and sometimes aggravating character: originally trained as a lawyer, he is said to have abandoned a professional career to seek his fortune as a poet.[5] As a young man, his greatest success was to have won the heart of a gentleman's daughter, Lucy Read (d. 1797). The Reads came from a well-established gentry family; her father was both Rector of Tenbury, Worcestershire, and the local squire. He expected his daughter to marry according to her status.[6] On discovering in 1754 that Lucy had secretly wedded the improvident Lawrence, her family disowned her, leaving the couple to survive by their wits.

When their fifth and last surviving child, also Thomas, was born on 13 April 1769, Lawrence senior was Supervisor of Excise in the busy port of Bristol, an office he apparently carried out with courage and honesty.[7] A month later he took on the White Lion Hotel in Broad Street, a substantial business in the centre of the city with a stable of post-horses running regularly to London and Exeter. As a young man, Lawrence had taken himself seriously as a poet; his verses still appeared occasionally in periodicals and the accounts of his hotels describe his large collection of books.

Fig. 2
John Keyse Sherwin (1751–1790), probably after William Hoare (c.1707–1792)
Master Lawrence
1783
Etching and engraving
29.9 × 23.5 cm
The British Museum, London

A chalk drawing of Lawrence by his son (fig. 3), made when the former was in his early seventies, conveys a robust and self-possessed character, well-dressed but old-fashioned in a frizzed wig. The maid at the Black Bear later recalled how he had 'an aversion to new clothes' and was 'a man of somewhat eccentric habits'.[8] He was also plagued by financial troubles. In the summer of 1773, he announced his departure from the White Lion (whose post-horses had succumbed to an equine disease) to take on a new business venture, the Black Bear in Devizes.[9] Young Thomas, then about six years old, remained in Bristol as a pupil at a small boarding school near Royal Fort House run by a John Jones.[10] Tom's schooldays ended after only a year or two; he continued education alongside his older sisters at home in Devizes.[11]

Devizes was then a market town of some importance, serving the whole of West Wiltshire. Situated close to the main London–Bristol road, it is roughly the same distance from Marlborough to the east, Salisbury to the south and Bath to the west, making it an ideal stopping point for travellers on the three-day journey to Bath from London. As well as being a hostelry where prosperous locals could refresh themselves on a market day, the Black Bear offered a comfortable and genteel place to stay. Guests included many of the leading cultural and political figures of the day, such as Samuel Johnson, Edmund Burke and John Wilkes.[12]

Contemporary accounts show that the Lawrences were a gifted family with varied interests far beyond what might be expected of the children of a country innkeeper. On her visit, Burney had been 'much surprised by the sound of a Piano Forte' and she and Mrs Thrale were impressed to find Lawrence's 'two pretty young girls, aged 13 and 16, singing and playing the piano'.[13] When the inn's contents were sold in July 1780, they included a substantial library and 'fine paintings and prints'.[14] The family's enthusiasm for literature, music and art was more than a pursuit of accomplishments simply for the sake of the social advantages they could bring a middle-class family; they arose from genuine talent and passion. Lawrence encouraged his youngest son to share his love of literature and trained him to recite verse as a form of social entertainment. Little Tom, who was impressing

Fig. 3
The Artist's Father, Thomas Lawrence
(1725–1797)
*c.*1797
Pencil with black and red chalk
23.8 × 18.2 cm
Iris & B. Gerald Cantor Center for Visual Arts at Stanford University; Alice Meyer Buck Fund

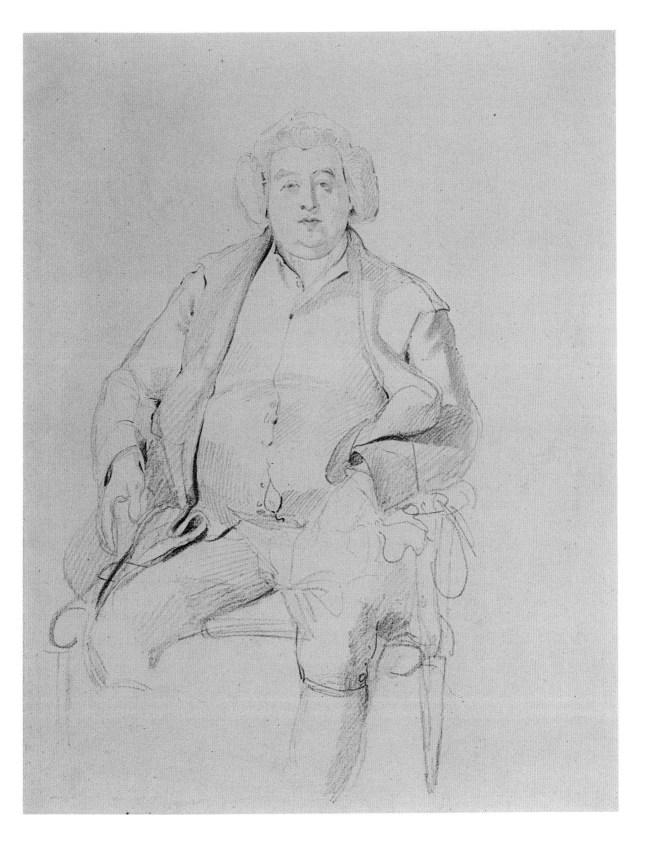

visitors with passages from Shakespeare and Milton by the age of five, was soon to discover a lifelong passion for the theatre.

Bath and Bristol were exceptional in having the only theatres with royal patents outside London. Under the management of John Palmer (1742–1818), the Bath and Bristol Theatres Royal had close business links with the London playhouses and were run jointly, so that the same actors could perform at both in one season, sometimes on the same day.[15] Some London actors returned to Bath regularly, sometimes breaking their journey at the Black Bear in Devizes where they were received with pleasure by the dilettante landlord and his stage-struck son.

The actor-manager John Bernard, performing in Bath in the 1777–78 season, recalls in his memoirs how Thomas Lawrence of Devizes was a regular visitor to the Theatre Royal: 'Lawrence frequently brought his boy to the Green-room, and we would set him on a table, and make him recite "Hamlet's direction to the Players." [...] The little fellow, in return for our civilities and flatteries, was desirous to take our likenesses the first time we came to Devizes.'[16] However impressive, Bernard suggests that young Tom's skills at reciting and reading verse were less remarkable than his drawing.

The long-reigning king of English theatre, David Garrick (1717–1779), visited Bath each year with his wife Eva Maria (fig. 4). He was a regular at the Black Bear and had a friendly relationship with his hosts. Mrs Garrick recounted how young Tommy (encouraged by his father) would invite them to sit in the summer house, where he recited the latest speeches in his repertoire and showed them his drawings.[17] Lawrence's hopes of gaining Garrick's interest for his son followed a precedent: it seems that in 1775 he had introduced an aspiring actor from Salisbury, Thomas Grist, to Garrick, and a successful theatrical career in Bath had followed.[18]

There are so many references to the little artist's drawings in letters, journals and anecdotes of the period that they must have been a memorable feature of many visits to the inn. The Lawrences' maid recalled a four-year-old Tom 'running up to me and saying [...] "sit as you are, and I will draw your picture" [...]

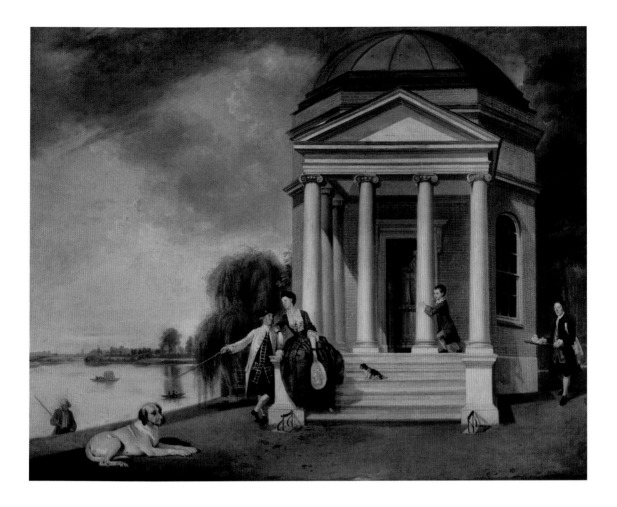

In a few minutes he produced what was always considered an excellent likeness of me. […] I shall never forget the pleasure with which his father caressed him when shewn this his first attempt.' Lawrence hung his child's portrait of the maid above the bar for all to admire and 'from this time numbers of persons became anxious to have their likenesses taken by a child in petticoats'.[19]

This description of a father's affectionate pride scarcely conceals the visions of wealth that must have been appearing before him. His wife told Mrs Thrale that her son 'had been taken to [London], and that all the painters had been very kind to him, and Sir Joshua Reynolds had pronounced him […] the most promising genius he had ever met with. Mr. Hoare has been so charmed with this sweet boy's drawings that he intends sending him to Italy with his own son.'[20] Reynolds (1723–1792), London's foremost painter,

Fig. 4
Johan Zoffany
(1733–1810)
The Temple to Shakespeare at Hampton House with Mr and Mrs Garrick
1762
Oil on canvas
99.7 × 125 cm
The Garrick Club, London

was a close friend of the Garricks, and it is possible that they or other guests at the Black Bear had recommended the boy to him. A connection with the artist William Hoare of Bath (c.1707–1792) is also more than plausible: his son Prince (1755–1834) had been studying in Rome since 1776. Several of the boy's admirers certainly encouraged him generously: a local clergyman, Rev. Dr Henry Kent of Potterne, gave him drawing materials and lent him Charles Rogers's *Lives of the Artists* (1778). However, Lawrence was reluctant to permit anything that he feared might adulterate the purity of his son's natural genius or a potentially lucrative trade in portraits.[21]

The earliest known drawing by Lawrence is inscribed 'Charles Waters Esquire of Bath pencilled by Sir Thomas Lawrence at the early age of 7 years.'[22] This sitter was presumably Charles Waters, proprietor of King James's Palace, a pleasure garden on the outskirts of Bath.[23] Similar drawings from the later 1770s are typically bust-length profiles in graphite pencil and occasionally ink, either on paper or vellum.[24] They are usually three inches high, essentially miniatures, and painstakingly trace the sitter's likeness and every detail of their costume. At this stage, Lawrence was only able to draw likenesses in profile: when the judge Lloyd Kenyon and his wife visited the Black Bear at the end of 1779, he asked Lady Kenyon to 'turn her side to me, for her face is not straight'.[25]

Some of these small drawings are striking for the prominence of the artist's signature, inscribed in disproportionately large copperplate letters and often including his age to emphasise Lawrence's reputation as a prodigy. This insistence on his youth marked the artist out as unique among so many other provincial portrait-makers and gave his early work a novelty value that made up for its technical deficiencies.

Less than a month after Burney's visit, the *Bath Chronicle* announced that the Black Bear was 'to be lett'. The advertiser, 'Mr T. Lawrence', was bankrupted and once again blamed bad luck, explaining that his establishment had suffered by repeated billeting of soldiers in his inn.[26] One of the trustees he appointed to wind up the business was a John Jones of Kingsdown Parade in Bristol, presumably the same schoolmaster who had educated his sons.[27]

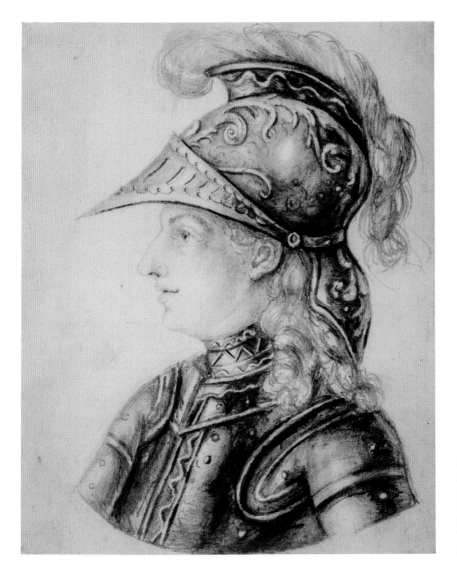

Fig. 5
Head of Minerva
1779
Metalpoint and
graphite on vellum
7.8 × 6.2 cm
Private Collection

Ever the optimist, Lawrence decided that the time had come to give up innkeeping and rely on his youngest son, who had just turned eleven, as the family's chief source of income. Towards the end of 1779, the Thomas Lawrences, father and son, had spent some time in Oxford, perhaps to explore the artist's potential earning value. It is not clear how long this visit to the university town lasted, but the local press declared young Thomas 'one of the most remarkable Instances of an early Genius ever known'.[28]

The only known work that can be firmly associated with Oxford is an imaginary head of Minerva (fig. 5) resplendent in armour. The later inscription on the backboard reads: 'Drawn at

Oxford by Master Lawrence at the age of 11 years.' The drawing is essentially a lady's profile dressed up in theatrical costume with careful attention given to the reflective surfaces of the chased armour and helmet. The artist seems to be taking pleasure in discovering all the variations of texture that a graphite pencil and old-fashioned metalpoint can produce – a delight that he conveyed years later in the exuberance of his oil paint and the great finished drawings of the late 1780s and 1790s.

Lawrence began to publicise his son's work in earnest by collecting subscriptions for an engraving. This print (see fig. 2 for a later 1783 edition), made in the busy London workshop of John Keyse Sherwin (1751–1790), was a portrait of the boy himself rather than a reproduction of one of his drawings: the product on offer was the artist as much as his art. His father understood the monetary value of celebrity and the role the print market could play in promoting it.

John Bernard later observed, 'Little Lawrence [...] excited the surprise of the most casual observer. He was a perfect man in miniature; his confidence and self-possession smacked of one-and-twenty.'[29] In Sherwin's engraving, he is neatly and fashionably dressed in a gentleman's three-piece suit and depicted not as an artist, but as a young orator or actor, standing to read aloud from *Paradise Lost* (*c.*1667) by John Milton. This Thomas Lawrence is to be recognised as a young gentleman of letters, not an artisan getting his hands dirty.

According to the artist's biographers, the portrait that Sherwin had copied was painted by Prince Hoare, who had returned to Bath from Italy in 1780.[30] However, a more likely author is Prince's father William Hoare, by far the more experienced and competent artist: Sherwin's original may be the 'Young Student, whole length' that Hoare exhibited at the Royal Academy in 1779.[31]

Lawrence published this print as an important investment in his son's future: it would serve as both calling card and advertisement. The dedication 'To the Nobility & Gentry in general, & the University of Oxford in particular, who have so liberally countenanced his pencil' emphasises the young genius's favour among the powerful and learned and his father's gratitude

to them. As well as many heads of Oxford colleges, the list of subscribers includes bishops, earls and the government minister Viscount Barrington, whose family were to remain important supporters of Lawrence.[32]

A later edition of the print (fig. 2, published in 1783) includes a reference to a 1781 collection of essays by Lord Barrington's brother Daines, a judge and amateur natural historian. His essay on the six-year-old musician William Crotch cites Lawrence as a phenomenon comparable to Europe's most famous child prodigy, Wolfgang Amadeus Mozart. He describes 'Master Lawrence, son of an inn-keeper at the Devises in Wiltshire. This boy [...] at the age of nine, without the most distant instruction from any one [...] was capable of copying historical pictures in a masterly stile [...] In about seven minutes he scarcely ever failed of drawing a strong likeness of any person present.'[33] By including the reference to Barrington's natural history essays, the engraved portrait becomes a record of a scientific specimen as well as a portrait of a would-be celebrity. The late eighteenth century experienced a fascination with child prodigies. Contemporary accounts suggest that the innkeeper Lawrence was anxious for his son to be seen as a raw, natural talent that had sprung up from nowhere and blossomed without cultivation.

By November 1780, the engraving was almost ready for subscribers to collect from the Lawrences' new address in Bath, the city that was to be their home for the next six years.[34] At this point, everything was in place for a successful new Lawrence enterprise: they had a unique product whose quality could only improve as Tom perfected his skills, a healthy market that refreshed itself regularly as seasonal visitors came and went, a reputation verging on celebrity and a solid foundation of influential contacts and advocates from various walks of life. Between 1780 and 1786, Bath enabled young Lawrence to grow from a provincial curiosity into a very promising painter.

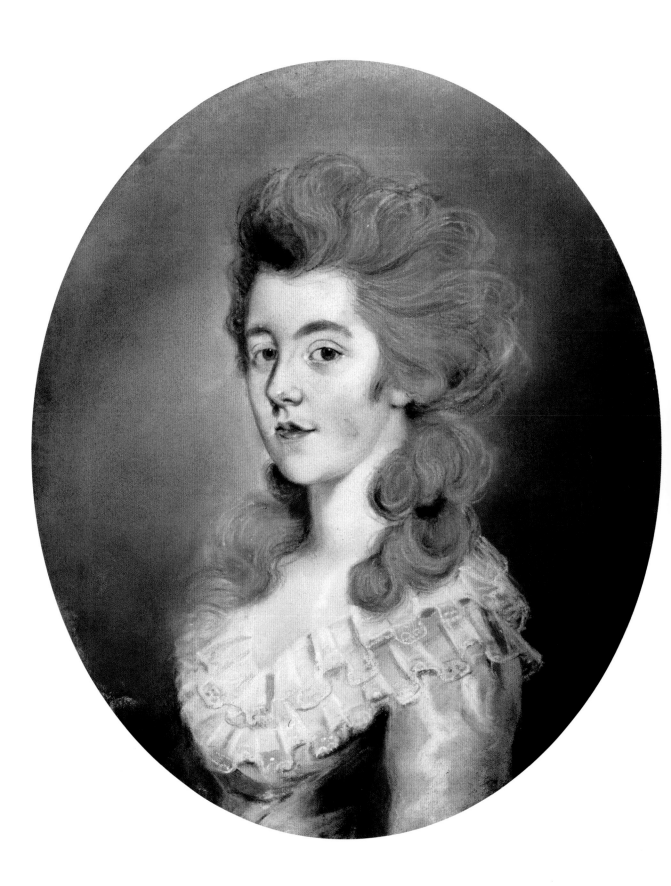

Striking Likenesses

During the eighteenth century, Bath became unlike any city in England: its growth as a spa resort turned it into a unique centre for leisure, healthcare, shopping and gambling during the annual 'Season' (roughly November to April), when the population swelled with visitors. The impact on the local economy has been vividly imagined in a drawing by Thomas Rowlandson (fig. 7). Against the background of a crescent, an aristocrat's carriage has drawn up outside a hotel. The noble party are greeted by musicians who rush to the fashionable lady in the carriage to have their hats filled with coins. Behind them, the hotel staff come out to greet their guests, much as the Lawrences might have done in Devizes. At the centre of the image, a little dancing dog stands on its hind legs, eagerly holding out a hat. The dog could almost be a metaphor for Lawrence the child prodigy, performing tricks for a delighted audience and charming them into dropping golden guineas into his hat.

Among Bath's many markets in luxury goods, one of the most significant was in pictures. There was a lively trade in prints and regular auctions of works from country houses or the collections of connoisseurs. Portraits were available to suit every budget, from silhouette profiles to grand oil paintings, but a precedent for work of exceptional quality and originality had been set by Gainsborough when he lived and worked in Bath from 1758 to 1774. In a competitive market, the fact that Lawrence was still a child and had been documented as a scientific phenomenon gave him a unique selling point which, enhanced by his engaging looks and manners, appealed to a broad audience.

Fig. 6
Georgiana, Duchess of Devonshire (1757–1806)
1782
Pastel on paper
30 × 24.5 cm
The Devonshire Collections, Chatsworth

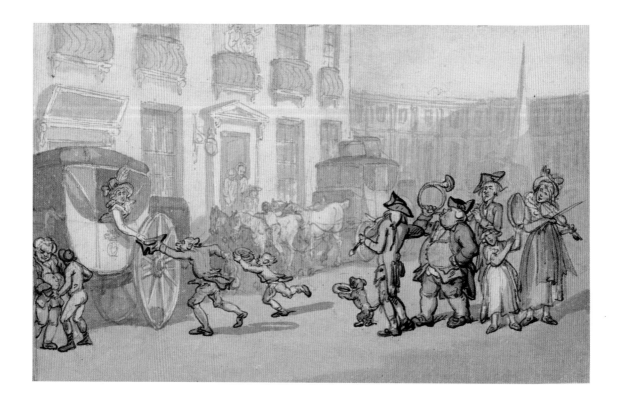

Fig. 7
Thomas Rowlandson
(1756–1827)
Comforts of Bath: Coaches Arriving
1798
Watercolour and ink over graphite on paper
11.7 × 18.7 cm
Yale Center for British Art, Paul Mellon Collection

At the opening of the 1780–81 Season, young Master Lawrence was presented to 'The Nobility and Gentry' in the pages of the *Bath Chronicle*. An advertisement announcing delivery of Sherwin's print also offered 'Striking Sketches of [...] Likenesses, without loss of time'. Those wishing to view the artist's drawings were invited to call at '14, St. James's-Parade (last house on right)'.[35]

St James's Parade is a street of terraced houses built around 1768 at the southern boundary of the medieval city.[36] Although the buildings themselves are elegant, with large Venetian windows overlooking the street, some backed onto one of Bath's shabbiest areas between the old city and the River Avon. The north-western block of St James's Parade had been gutted in the summer immediately before the Lawrences' arrival, when the anti-Catholic Gordon Riots spread from London to Bath. A crowd of 'ill-disposed fellows' set fire to the newly built Catholic chapel and the resident priest, Dr John Bede Brewer, fled for his life as the fire spread through the whole block, leaving 'nothing but the walls'.[37] The street must have had a melancholy aspect that autumn.

During his first year or two in Bath, most of Lawrence's work was still done in pencil, but the improvement in his skill by 1782 is evident in two portraits of family members. A drawing of his sister Anne, now in the British Museum (fig. 8), is considerably more competent than those of the Devizes period, but still in profile and on vellum. It is mounted with a portrait from around the same time of their cousin, Miss Hammond (fig. 9), and the two show how much the unformed artist's style could vary as he experimented with styles and techniques. Miss Hammond's portrait is very formal, with every pleat and ribbon of the girl's

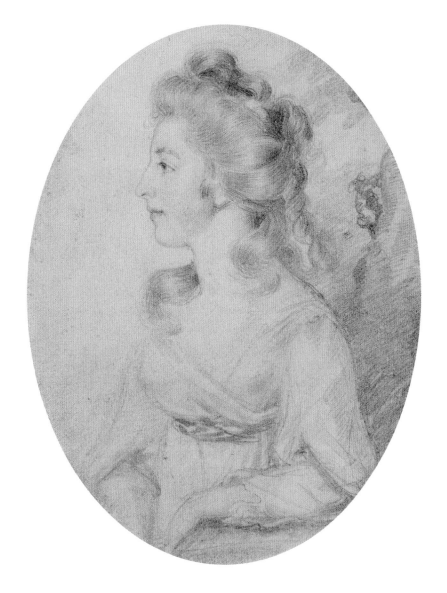

Fig. 8
Miss Anne Lawrence
(1766–1835)
1781
Graphite on vellum
10.3 × 7.8 cm
The British Museum,
London

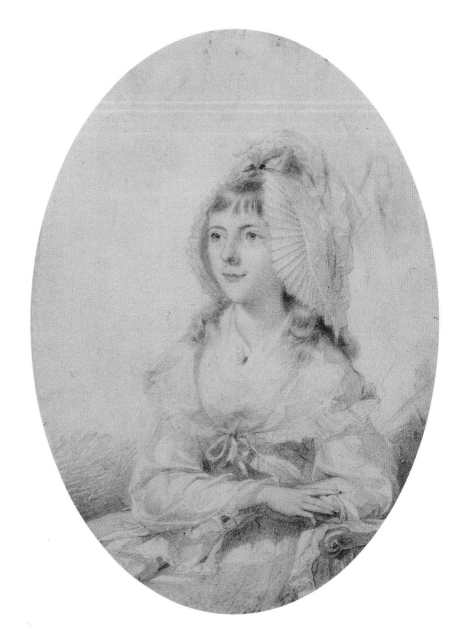

Fig. 9
*Miss Hammond, Cousin
of the Artist*
1781
Graphite on vellum
13.7 × 9.9 cm
The British Museum,
London

rather fussy attire noted exactly. The treatment of Miss Lawrence,
on the other hand, is more imaginative and idealised: she is set in
a landscape in profile, as in an antique medallion, and her dress
and loosely curling hair are at once less formal, less precisely
delineated and more adult than her cousin's. With Lawrence's
graphite self-portrait from around the same time (fig. 1), the
Hammond drawing is the first that dares to forgo the full profile;
without that distancing effect, his portraits suddenly burst into

life. Amid all the detail of her elaborate dress, Miss Hammond's eyes shine warmly with energy and character and she seems ready to jump up from her chair.

By November 1782, the Lawrences had moved to 2 Alfred Street, a recently built four-storey townhouse overlooking the fashionable new Upper Assembly Rooms. An artist could not have chosen a better location to carry out his business. This terrace of north-facing townhouses completed in 1776 was part of the move of the city's epicentre from the old medieval heart around the Abbey and Guildhall to the more orderly and airy surroundings of John Wood's squares and terraces. In the 1760s, Gainsborough had similarly moved north-westward from the Abbey Churchyard in the middle of the medieval city to the new Circus, while Joseph Wright of Derby (1734–1797) later lived nearby in Brock Street. Lawrence was not the only artist to choose Alfred Street: painter and pastellist Lewis Vaslet (1742–1808) lived here until January 1786, and miniaturist Joseph Daniel (c.1760-1803) was at No. 8 in 1799.[38]

At the far end of Alfred Street, opposite the portico of the new Assembly Rooms, lived Rev. Dr Thomas Wilson. Four years earlier, Wilson's home, Alfred House, had been famous for its literary salons presided over by the much-satirised historian Catharine Macaulay, but by the time the Lawrences became his neighbours Wilson was elderly and infirm, deeply wounded by Macaulay's marriage to a much younger man. One of Lawrence's first jobs in Bath was to prepare a portrait of Dr Wilson for Richard Cruttwell, publisher of the *Bath Chronicle*, to be engraved by Sherwin. Lawrence senior had been advertising in the *Chronicle* since 1773 and was probably well known to Cruttwell, a notable public figure who moved in similar circles among the entrepreneurs, actors and writers of Bath.[39] The artist based Wilson's portrait on a painting by Wright of Derby, who had worked in Bath for two Seasons in the 1770s: the good doctor's portrait was one of the very few Wright had been able to paint while in Bath, and must have still been in Alfred House at the time Lawrence copied it.[40]

While mastering the use of graphite, Lawrence also began to offer portraits in crayons, the soft, brightly coloured chalks

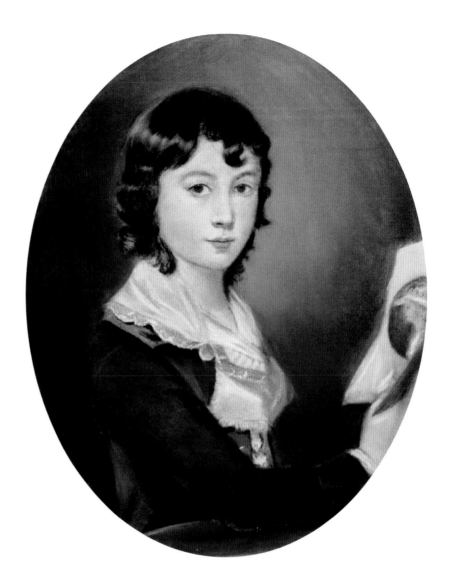

Fig. 10
Self-Portrait
*c.*1781–2
Pastel on paper
25.7 × 21 cm
The Vyne, National
Trust, Hampshire

that were so popular at the time. Crayons, better known today as pastels, are a useful midway point between drawing and oil painting: a dry medium, they are used on rough paper or vellum, but the rich colours may be layered and blended to create a painterly effect and a wide range of textures. For short-term visitors to Bath, a pastel portrait could be framed and delivered within days, whereas oil paintings would need months of drying time. Pastel was also popular with amateurs as it required relatively little space and equipment, little more than a table-top easel and box of crayons; thus equipped, Lawrence could easily visit sitters in their own lodgings.

The earliest datable pastel portraits are from 1782 or possibly 1781, when Lawrence and his father were working hard to establish his reputation. Among them are a pair of self-portraits, one of them inscribed 'The portrait of Mr Lawrence at 12 years – by himself'.[41] The more polished of the two (fig. 10) makes the most of the rich qualities of pastel, delighting in the varied and detailed textures of soft linen and lace, glossy curls artfully arranged to frame the face and the vibrant colours of a smart blue coat with red facings. The subtly toned, pale flesh has been observed with care and the eyes, nose and lips underlined with great delicacy. It presents the boy as a friendly, confident figure, turning to make eye contact with the viewer while showing off a sample of his work.

The self-portraits were an effective piece of self-publicity, presumably made for exhibition in Alfred Street. There were also those who wanted Lawrence's portrait for themselves: in a letter from as early as 6 December 1780, Lady Frances Harpur of Calke Abbey writes to Lawrence requesting 'your own likeness', adding: 'pray do yourself justice, and make me a pretty picture.'[42] She and her husband were keen to finance the boy's artistic training and to send him to Italy. It was in response to the Harpurs' generous offer that Lawrence senior is said to have responded: 'Sir, my son's talents require no cultivation.'[43]

The question then arises of how Lawrence did cultivate his talents, since Bath was amply supplied with drawing masters and many professional artists also gave lessons. To some extent, he may have learned about composition and the handling of media by studying or copying whatever pictures he could find; a number of manuals existed with detailed instructions for working with pastel, such as John Russell's *Elements of Painting with Crayons* (1772 and 1777).

William Hoare, Bath's longest-established painter and pastellist, lived around the corner from Alfred Street at 4 Edgar Buildings and evidently had a role in Lawrence's artistic formation.[44] He was now in his seventies and a much-respected citizen of Bath, a founder member of the Royal Academy and well connected in London's artistic and political circles. Since Gainsborough's return to London, he had been without a rival as Bath's leading artist and

was a sought-after teacher. Another neighbour whose influence is discernible in Lawrence's pastels is Lewis Vaslet, who had lived in Bath from 1775.

Lawrence's earlier pastels sometimes give the impression that the artist was bored by his sitters and resenting the drudgery of drawing for money, but in 1782 he found inspiration in a woman who was at once beautiful, charming and famous: Georgiana, Duchess of Devonshire. One of the most portrayed women of her time, sitting to artists was just another of the social rituals making up her daily round, and the child portraitist must have presented a welcome novelty. Her likeness by the thirteen-year-old artist reveals the vivacious character that made her a popular celebrity. Lawrence's informal portrait (fig. 6) uses the varied textures of pastel to depict the Duchess's powdered hair and chalky complexion, the soft sheen of satin and a simple muslin collar.

Aged twenty-five and already married for some years, Georgiana had come to Bath to take the waters, having suffered several miscarriages. Bath was also a place to indulge her love of fashion and addiction to gambling. The following summer, the Duchess received the gift she had hoped for from Bath's healing waters: Lady Georgiana Cavendish, her first child, was born in July 1783. Lawrence later recalled how, on a subsequent return to Bath, the Duchess asked him to make the child's portrait. Rather than take her baby out, the Duchess invited Lawrence to work 'in her own dressing room', leaving the artist with his little sitter and a nurse. 'One morning he was surprised by a most delicious gale of perfume [...], he turned his head suddenly and his cheek came in contact with that of the Duchess, who was peeping over his shoulder in her dressing-gown [...] He was so dreadfully confounded [...] that the good-humour'd Duchess broke up the sitting.'[45]

This episode took place in 1784, when Lawrence was fourteen or fifteen. It shows how sitting for a portrait by the boy wonder of Bath and being scrutinised by those famous eyes was a form of entertainment in itself. The way Lawrence's self-portraits present the image of a confident, professional young artist suggest that his drawing was as much of a self-conscious performance as his recitations of Shakespeare. Throughout his life, Lawrence's art

continued to be a form of spectacle, a display of virtuoso painting or drawing designed to impress an audience; they expressed an energy and imagination that first came to public attention in those childhood theatrical performances at the Bear.

Although Lawrence might have used the Duchess of Devonshire's celebrity to win clients, this privately commissioned likeness of her may never have been seen in public. By this time, however, the artist was working on a project that would tie him permanently to the petticoats of celebrity: a portrait of the actress Sarah Siddons.

Siddons was twenty-three in 1778 when John Palmer invited her to Bath following an unsuccessful debut at Garrick's Drury Lane theatre. In the smaller setting of Bath, free from the rivalry of more experienced actresses, she soon became the undisputed star of tragedy. Over four Seasons her extraordinary talent and imposing beauty captured the public imagination, until she became something of a cult figure in Bath and Bristol. In 1782 she rejoined the company at Drury Lane for the exceptional salary of £10 a week.[46] The fervour of enthusiasm with which she was received in London was reflected in the number of portraits of her that appeared that year. Like Garrick before her, Siddons, a self-proclaimed 'ambitious candidate for fame' understood the value of portraiture in nurturing and supporting that fame.[47] She collaborated actively with artists, taking time from her exceptionally busy professional and family life to sit for Gainsborough, Reynolds, George Romney (1734–1802) and many others. When in Bath, she sat for Thomas Beach (1738–1806), whose portrait of Siddons as Melancholy was published in mezzotint within weeks of her triumphant return to Drury Lane. The market was quickly flooded with prints of Siddons in her most successful tragic roles, and Lawrence did not miss the opportunity to participate.

In June 1783, Sherwin's engraving of Master Lawrence (fig. 2) was reissued with an added inscription announcing 'A Print of M^rs Siddons, in the Character of Zara, Drawn by Master Lawrence, & Engraved by J. R. Smith'. John Raphael Smith's mezzotint engraving of Siddons (fig. 11), after an original by Lawrence, was

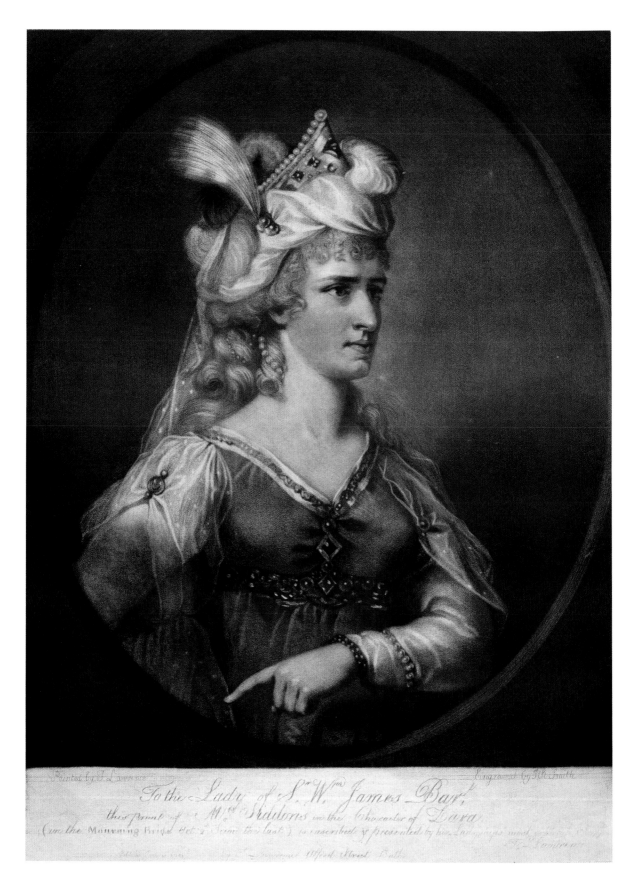

Painted by T. Lawrence Engraved by R. E. Smith

To the Lady of Sr Wm James Bart

this Portrait of Mrs Siddons in the Character of Zara
(in the Mourning Bride Act 5 Scene the last) is inscribed & presented by his Ladyships most
T. Lawrence

designed to appeal to the luxury end of the print market, a joint venture between Smith in London and the Lawrences in Bath. Here, Lawrence has captured some of the dynamism and power of the actress's expression and gestures, partly recalled from stage performances but probably combined with private sittings. The head-and-shoulders format of this image allows Lawrence to portray Siddons's famously striking beauty in intimate detail. She was renowned for her tall stature, pale skin and powerful profile, emphasised here by Smith's skilful use of mezzotint to create dramatic contrasts of light and shade. Lawrence has paid particular attention to her large deep brown eyes that struck many with their intensity; years later, describing his first encounters with Siddons, he wrote verses that describe 'the smiting lustre of her eyes'.[48]

After moving to London in 1787, Lawrence renewed his acquaintance with Siddons as performer, sitter and friend; she was to become one of his most constant mentors and companions in a mutually dependent relationship that spanned their parallel professional and private lives.

It is easy to condemn Lawrence's father for exploiting his youngest child as the family's main source of income when his own business ventures had failed. However, his encouragement of his son needs to be seen in the context of its time. Few children – girls or boys – of Thomas's age had the luxury of avoiding work; even the most privileged were expected to take on responsibilities and training in preparation for adult life. By taking the risk of setting up his son as a freelance artist, Lawrence avoided binding him to the drudgery of a seven-year apprenticeship and the lower social status of a tradesman. As it was, the income as well as the risks relating to the enterprise remained in the family and allowed them to live respectably as near equals with Bath's more genteel residents.

Lawrence turned fourteen in the spring of 1783. By this time, his work in both pencil and pastel had reached a level of competence that assured a steady income for his family. By now, though, he understood that his crayon portraits, however pleasing, were not enough to satisfy his creative imagination or to take him into the competitive art world beyond Bath.

Fig. 11
John Raphael Smith (1751–1812), after Thomas Lawrence
Sarah Siddons in the Character of Zara
1783
Mezzotint
37.8 × 27.5 cm
The British Museum, London

Old Masters and New Horizons

As Lawrence was celebrating his fifteenth birthday, Alfred Street was in deepest mourning: Dr Wilson, friend to the prisoners and the poor of Bath as well as to Lawrence and Wright of Derby before him, had died. Undertakers decked out Alfred House with their finest black plumes, velvet and candles for the visitors paying their respects. A few weeks later, the house hosted a sale of Wilson's 'Elegant Houshold [sic] Furniture, capital Library of Books, [...] engravings [and] Paintings, including [...] Hercules by Michael Angelo'.[49] The young artist from down the street must have been fired with the hope of buying from a collection that he may have known well by then.

Wilson's sale fell at the very end of the annual Season; from May to October, Lawrence's commissioned portrait work would have fallen off, leaving him time to study and experiment with subjects other than portraits. Presumably during the summer, his father permitted him some time off to enjoy life outdoors or visit relatives: we hear of him riding, playing billiards and indulging in a 'passion for pugilism'.[50] The daily grind of drawing one stranger after another ('this dry mill-horse business', as he later called it) did not satisfy his ambition, even if it paid his father's bills.[51] To move beyond face-painting, a young artist needed to study the Old Masters, nurture the creative imagination and develop an exceptional technical ability.

Lawrence had been inspired by the Old Masters since at least the age of eight, when he is said to have been captivated by a painting by Peter Paul Rubens at nearby Corsham Court; Barrington's note

Fig. 12
George Isted
(1754–1821)
*c.*1786
Pastel on paper
32.3 × 27.2 cm
The Fitzwilliam
Museum, Cambridge

mentions a drawing of Peter Denying Christ of the boy's own composition.[52] For an aspiring painter, Bath was a rich source of inspiration and Lawrence's excellent contacts opened doors to many private collections in and around the city. One of the most important belonged to Hon. Charles Hamilton, who had arrived in Bath in 1774, following the sale of his innovative landscape garden at Painshill in Surrey. In the 1780s, he had a substantial house on Lansdown Hill and what Gainsborough had described as 'really very fine Pictures'.[53] Among them was a copy of Raphael's famous *Transfiguration* (1516–20), a masterpiece valued by artists for its daring composition, colour and lighting effects and a range of gestures and expressions that served as a catalogue of the passions.[54] Aged thirteen, Lawrence made a copy of Raphael's masterpiece in pastel on a suitably ambitious scale: at four feet tall, it was several times the size of his portraits (fig. 13).

On 5 December 1782, the *Bath Chronicle* published a sonnet 'By a Lady', entitled 'On seeing Master Lawrence painting the Figure of Our Saviour from Raphael's famous Picture of the Transfiguration', the author may have been the 'sweet youth's' Alfred Street neighbour Jane Bowdler (d. 1784).[55] In 1784 Lawrence was granted a special award of a silver palette and five guineas by the Society of Arts in London in recognition of this picture's excellence.[56]

For all his admiration of Raphael, Lawrence's greatest love among the Old Masters was Michelangelo. He later remembered how 'when a boy of fourteen or fifteen at Bath, night after Night [...] I copied the Figures [...] of the Prophets and Sybils [from the Sistine Chapel] from the Prints [...] I felt an Image of Grandeur in them that I was impress'd with by no other Work.'[57] In the Sistine Chapel frescos, with their images of Creation and Redemption, Lawrence found the same narratives and powerful figures as in Milton's *Paradise Lost*, a book that features in so many anecdotes of his early life that it must have been something of an obsession for him. He 'immediately afterwards drew in Chalks colossal Heads of Satan, Adam and Eve, Raphael and Michael', the products of 'a mind [...] strongly and singularly excited'.[58] Lawrence later wrote of a work he was composing with these

Fig. 13
The Transfiguration, after Raphael (1483–1520) 1782
Pastel on paper mounted on canvas 117.5 × 73.7 cm
Yale Center for British Art, Paul Mellon Fund

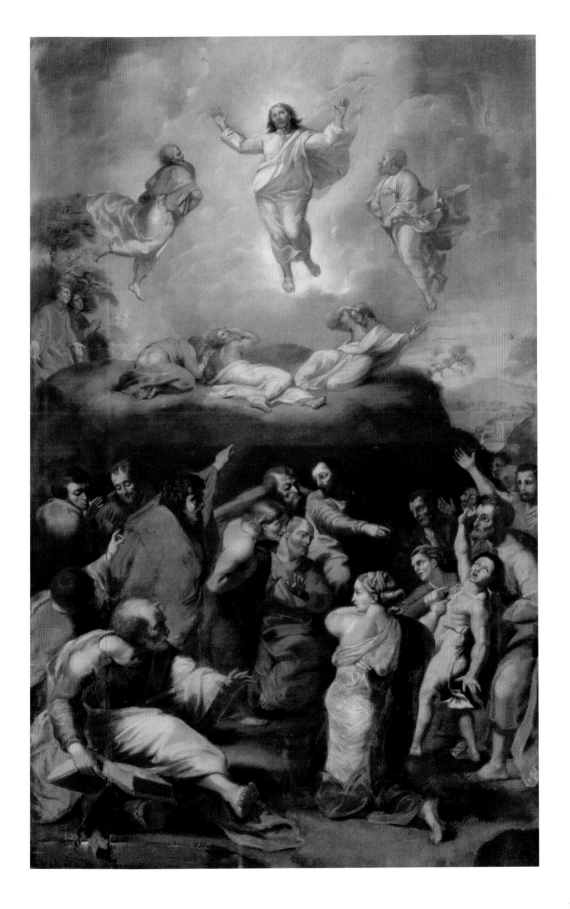

figures.[59] The recipient of the letter was Thomas Falconer, son of Dr William Falconer, the friendly and cultured host at whose home Lawrence, now approaching seventeen, 'passed several evenings every week'.[60] Falconer and his wife held regular Monday soirées for cards, conversation and needlework and their home seems to have been a place where Lawrence was warmly encouraged in his interests in art and literature.[61] According to Richard Warner, a collector of Bath anecdotes, it was here that 'many of the best of the artist's early drawings' were 'begun and completed'.[62]

Although a few figure studies and copies in pastel after Italian paintings exist from Lawrence's Bath period, no finished original compositions are known. The nearest example is a small unfinished graphite drawing, *The Hermit's Tale* (fig. 14). It illustrates the closing scene of a Gothic romance in verse by Sophia Lee (1750–1824), in which a man makes his confession before dying in the arms of a monk.[63] The figures are traced with minute precision in a composition that was to rely on contrasts of bright torchlight and deep shadow for its effect. The dying man reaching out a limp arm is a reverse version of Michelangelo's *Creation of Adam* (1508–12), giving up his last breath rather than receiving his first.

Sophia Lee was the daughter of a successful acting couple. She had grown up, like Sarah Siddons, on the provincial theatre circuit but settled in Bath when her father John Lee managed the Theatre Royal.[64] When he died in 1781, Sophia and her sisters invested profits from her play *The Chapter of Accidents* (1780) to establish a girls' school a short distance from Alfred Street.[65] The Lee sisters remained friends and confidantes of Lawrence for the rest of their lives.

The Hermit's Tale was published in 1787, but without Lawrence's illustration. Two years earlier, some of his drawings did succeed in getting into print thanks to another versifying member of Bath's theatrical circle. As an actor, Samuel Jackson Pratt (1749–1814) had been known by the stage name of Courtney Melmoth, but in Bath he was more familiar as a bookseller and proprietor of the circulating library at the top of fashionable Milsom Street, 'the *best* as well as the cheapest in town'.[66] As a poet, Pratt was responsible

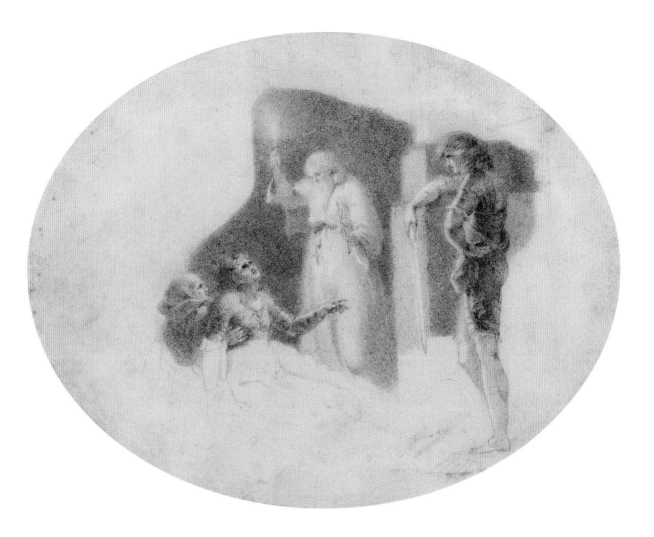

for the epilogues that Mrs Siddons delivered at her farewell to Bath and return to London. In 1785 he published a volume of *Landscapes in Verse*, illustrated with two vignettes by Lawrence, 'that amiable young Artist'.[67]

With his father's amateur interest in poetry-writing and theatre, it was natural for Lawrence to find himself part of an extended network of writers and performers. The circle included poet Mary Alcock (*c*.1742–1798), the Lawrences' widowed lodger and the neighbouring Bowdler family.[68] When Jane Bowdler died in 1784, her sister Harriet issued a posthumous volume of her verses printed by Cruttwell, with a portrait after Lawrence. Harriet and her brother later issued *The Family Shakespeare* (1807) that made their name famous.

Fig. 14
The Hermit's Tale
1786–7
Metalpoint and
graphite on vellum
9.5 × 12.1 cm
Private Collection

Another friend and neighbour of the Bowdlers, Mary Hartley (1736–1803), was also an important supporter for Lawrence.[69] Through her half-brother David Hartley, she was well connected in political circles, but her own friends included many of the Bluestocking set – the group of women and men that gathered at the London homes of Elizabeth Montagu and her friends to discuss literature and ideas rather than play cards. Hartley was a gifted artist in her own right, much praised by her contemporaries, including Horace Walpole; Lawrence claimed to prefer her drawings to Gainsborough's.[70] It is tempting to see Hartley (who corresponded enthusiastically on landscape composition with theorist William Gilpin) as one of those who introduced Lawrence to landscape composition. Like many who had retired to Bath, she suffered from poor health and was virtually housebound, living in her brother's house in Belvedere, a short walk up Lansdown Road from Alfred Street.

By 1786, Lawrence's portrait compositions had reached a much higher level of sophistication than the simple profiles of his first Bath works. They often include hands and the whole upper body, usually with a background of hangings or, more often in the case of ladies, an imaginary landscape. In the early 1780s, his price for an oval portrait in pastel, about 12 by 10 inches, was a guinea. By the time he left Bath permanently in 1787, he was charging five guineas and earning five times more than his older brother Andrew, a clergyman at nearby St Michael's.[71] The pastels are typically enclosed in a gilded oval frame of a particular style that suggests portraits were offered as a package complete with glazing and framing.[72] Their most idiosyncratic feature is the inscription inked onto the backing paper by the artist, giving his signature, date and age, and instructions for care: 'Be pleased to keep from the sun & damp' and occasionally 'must not be shook'. Although versatile and easy to use, pastel is also a fragile medium that requires special care, and Lawrence's caution to his clients reflects a concern for the quality and longevity of his materials.

The portraits of brothers George and Samuel Isted recently acquired by the Fitzwilliam Museum (fig. 12) show the level of technical skill that the artist had reached on the eve of his

Fig. 15
Jane Nash Linley (1768–1806)
*c.*1786–7
Pastel on vellum
32.5 × 27 cm
John Mitchell Fine Paintings, London

seventeenth birthday.[73] His use of colour and tone to depict flesh and all the subtle variations in the texture and pigmentation of his sitters' faces, powdered hair and clothes shows how Lawrence conceived pastel as a form of painting and partly explains how he could have made the transition to oil painting so quickly and smoothly soon afterwards. According to the 1806 memoirs of poet Richard Cumberland, the Isted family were close friends of the poet and his sister Mary Alcock, the Lawrences' lodger.[74]

Jane Nash Linley (fig. 15) was also more than a casual passer-by. During the 1770s the Linley family had been a Bath institution: Thomas, the father, was director of music for the new Upper Rooms from 1771. His older children, Elizabeth, Thomas and Mary, were exceptionally talented and beautiful musicians who, like young Lawrence, were both encouraged and overworked by their father; Elizabeth and Thomas made their Covent Garden debut aged twelve and eleven respectively. In 1776, Linley moved to London as musical director of the Drury Lane theatre, leaving his three youngest children in the care of various friends and relatives. The family were also closely associated with the Lee sisters and their school.[75] One of Lawrence's earliest pastels is a portrait of Maria, the third Linley daughter (c.1782–84),[76] and it is likely that his sister Anne stayed with the Linleys in Norfolk Street, London.[77] Jane was the sibling closest in age to Lawrence, who portrayed her as a young lady in her late teens. The arched brows and deep-set eyes are typical of his female portraits and imaginary figures at this time, but Lawrence has abandoned the strong blues and reds of his earlier pastels for a limited and sophisticated palette, the bold pink hat and fluffy muslin frock standing out against the austere darkness of the background. The painterly use of soft crayons looks forward to the energetic oil paintings of the late 1780s and 1790s.

Some of the best pastels made towards the end of Lawrence's time in Bath appeared in the Royal Academy exhibition of 1787. Two of them were fancy heads, a genre that offered the artist and his market double service: the portrait format was consistent with his commissioned likenesses, but the choice of subject allowed him to enter his imagination and express fantasies nurtured by

Fig. 16
Mad Girl
1786
Pastel on brushed vellum
46 × 36.5 cm
Philadelphia Museum of Art. Purchased with the SmithKline Beckman Corporation Fund, 1985-51-1

Following pages:
Fig. 17
Abel Rous Dottin
(1768–1852)
c.1784
Graphite on paper
22.5 × 18.6 cm
The Holburne Museum, Bath

Fig. 18
Samuel Dottin
(1770–1797)
c.1784
Graphite on paper
22.2 × 18.7 cm
The Holburne Museum, Bath

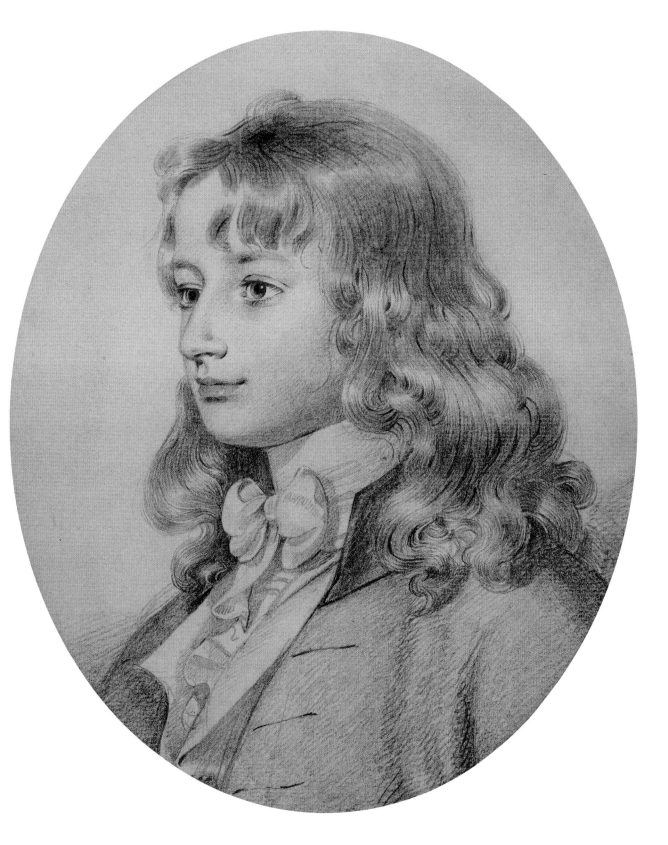

his reading, theatre-going and study of Renaissance and Baroque masters. Two of the earliest, a *Priestess* with flashing eyes and the afflicted *Vestal Tuccia* both carry the echoes of Mrs Siddons as their tragic muse.[78] The *Mad Girl* (fig. 16) owes much to the Italian masters but also follows the fashion for subjects drawn from popular contemporary literature: the inscription quotes from the ballad about 'a maid in Bedlam' awaiting the return of a lost sailor.

Lawrence also continued to perfect his portraits in pencil. His meticulous studies of Abel Rous Dottin and his brother Samuel (figs. 17 and 18) depict two boys who, like the artist, are beginning to turn into men. The qualities typical of his later portraiture are already present: the emphasis on bright, strongly highlighted eyes and glossy hair, the varied textures of wool, brass and silk, and a slightly uneasy sense that any imperfections the subject may have had have been smoothed away. According to old labels on the backing of these drawings, the Dottins were schoolfriends of Lawrence. Like many wealthy boys at school in Bristol in those days, their father was a major landowner in Barbados. He died in 1783, leaving the boys his joint heirs; the sale of effects from his substantial house in Prince's Buildings, Bath (the terrace parallel to Alfred Street) was announced in March 1784.[79]

By the age of sixteen, Lawrence must have felt increasingly frustrated with the limitations of pastel, a medium associated with amateurs, women and children.[80] Although the artist always maintained the impression that he was self-taught and his father seems to have gone to some effort to conceal the identity of his teachers, he must have received some training in mixing and handling oil paint in Bath, perhaps at the expense of a patron. There might have been some involvement from William Williams (active 1758–97), who published a short 'Essay on the Mechanics of Oil Colours' in Bath in 1787.[81] In his 1785 letter to Thomas Falconer, Lawrence mentioned that he was studying anatomy, presumably by copying from printed diagrams; he may have attended life drawing classes arranged by Thomas Beach.[82]

Despite the success of his drawing, young Lawrence's heart was still set on a theatrical career and he approached John Bernard,

back in Bath for the 1785 Season, for advice. Bernard later recalled how, concerned about the risk to the family finances posed by his son's acting ambitions, Lawrence senior had begged him and Palmer to dissuade the boy. After a short and clumsy audition, Palmer declared that the young man 'did not possess those advantages which would render the Stage a safe undertaking'.[83] Lawrence reluctantly agreed to abandon his dream of becoming an actor, but his love of drama and performance never left him, becoming infused into his expressively virtuoso painting style. an adult, his passion for the theatre spilled into his choice of subjects and his early friendship with actors was to remain a foundation of his social life.

Just as the eleven-year-old Lawrence had left Devizes for Bath with enough skill, confidence and contacts to make a living in Bath, so seven years later he was able to settle in London. He still had much to learn, but his reputation had gone before him and the capital had all the opportunities for training, publicity and companionship he needed.

Risking my Reputation

My dear Mother, // I think myself much obliged to you for the Books you sent me and the shirts. […] I am now painting a Head of Myself in oils, and I think it will be a pleasure to my Mother, to hear it is much approved of. […] To any but my own Family, I should certainly not say *this*; but, excepting Sir Joshua, for the painting of a Head, I would risk my Reputation with any Painter in London. // […] Your ever affect.ᵉ & Dutiful son, T. Lawrence.[84]

This letter probably dates from summer 1787, when Lawrence had been living in London for a few months. He seems to have transferred from Bath in stages: some accounts have him travelling to London in 1786 after spending the summer in Salisbury.[85] By April 1787, he and his father were living in Leicester Square, from where he sent those first half-dozen samples of his work to the Royal Academy exhibition.[86]

The artist, now eighteen, was working hard to gain a foothold in London. There is a sense of urgency about Lawrence's letters from this period as he seeks to make a name for himself in a much larger and more competitive market. A number of other very promising young artists, such as John Opie and John Hoppner, were already gaining favourable attention from the art establishment. Through the friends and patrons who had supported him in Bath, Lawrence was able to find his way quickly into well-disposed social and artistic networks. Mary Hartley had seen him off to London with a bundle of letters of recommendation that opened doors to private

Fig. 19
Queen Charlotte
(1744–1818)
1789
Oil on canvas
239.5 × 147 cm
National Gallery,
London

collections in London townhouses; she arranged for Prince Hoare to take him to the studios of both Gainsborough and Reynolds.[87] Writing to thank her, he relayed that 'Lady Middleton [...] has kindly offered me the view of her pictures at all times, with liberty of copying any that I wish, which I shall immediately avail myself of, and take this opportunity to improve in the study of oils, which is what I much long for.'[88] Prince Hoare had urged Lawrence to abandon pastels in favour of painting, 'practice being the only thing requisite for my being a great painter'.[89]

London in the 1780s was the 'portrait capital of the world' with at least 111 portrait painters active that decade.[90] For the past twenty years, their leader had been Reynolds, now less productive as his eyesight and hearing failed but no less influential. Gainsborough was living his final months, but Romney was still busy. During his first Season in London, Lawrence was able to study the work of all of them at first hand; he admired Reynolds's most. Having secured an interview with Sir Joshua, he brought him an example of his work, probably the 'Head of Myself in oils' that he mentioned to his mother. Reynolds is said to have shown great interest: 'It is very clear you have been copying the old masters, but my advice to you is, to study *nature*.'[91]

In London as in Bath, Lawrence introduced himself to his new audience with a self-portrait. His first head in oils exists in two versions which, as Reynolds noted, have the appearance of a pastiche.[92] The seated self-portrait illustrated here (fig. 20) may have been a second attempt. It depicts the artist in a complex and sophisticated pose, a three-quarter-length composition on a small, portable canvas of a size more often used for heads. For the artist who had recently renounced a possible acting career, this is something of a debut performance, self-consciously crafted so that the young man no longer appears as a prodigy to be marvelled at but as an adult and professional in a serious and sober black suit enlivened by a streak of ochre waistcoat. The legacy of Rembrandt, that great self-portraitist and experimenter, is clearly visible in the theatrical lighting, subdued colour and deliberate lack of finish.

Although legally still a minor, Lawrence has depicted himself as a gentleman. He has tied his long hair in an old-fashioned *queue*

Fig. 20
Self-Portrait
*c.*1787
Oil on canvas
63.5 × 50.8 cm
Private Collection

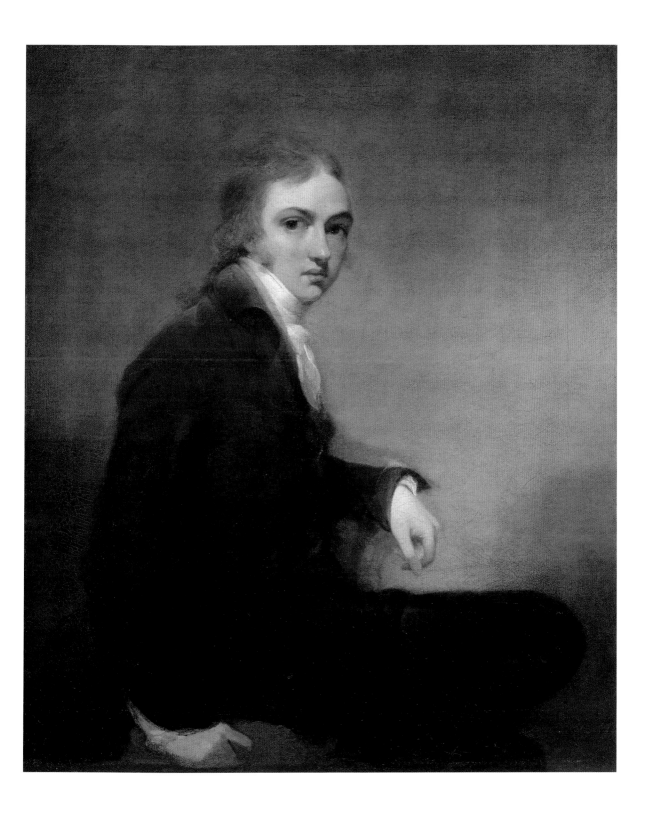

while hiding its natural lustre with powder. The fringe usually worn by boys and girls has been scraped back with pomatum, but refuses to lie flat, as though protesting at being forced to grow up. There is a malleable, almost melting softness to the pink face and Lawrence's eyes seem larger than ever, giving him a half-formed appearance.

The artist had recently claimed to Mary Hartley that 'the great end of painting' is 'expressing with truth the human heart in the traits of the countenance'.[93] His aim in this portrait, besides demonstrating his technical skill in oil paint, is to show his ability to reveal the inner man. This image of an adolescent newly arrived in a strange city barely conceals his apprehension and nervous energy beneath the bold, direct gaze and adult clothing. The young Lawrence twists uncomfortably in his chair, gripping the seat as he turns to look at himself in a mirror. Smudges of red upholstery appear to spill from the chair like splashes of blood, executed with a confidence that must have impressed many.

In painting as in drawing, Lawrence quickly reached a remarkable level of competence. His method of working in oil was unusual and painstaking: although he very rarely made preliminary drawings, his confidence as a draughtsman with pencil and chalk was literally the foundation of his paintings. According to one of his earliest biographers, 'His constant practice was to begin by making a drawing of the head full size on canvass [sic]; carefully tracing in dimensions and expression. This took up one day: on the next he began to paint.'[94] This initial drawing from life gave the finished portrait its immediacy and likeness 'because tho' it may be afterwards effaced by the colour, yet it serves to impress the object on the memory and the hand naturally follows the path it has trod in before.'[95]

An unfinished portrait of a little girl from around 1790 (fig. 21) has been painted using this technique. The image is traced in confident, liquid lines and areas of colour are built up with repetitive, brick-like brushstrokes, as seen on the child's sleeve and elbow. By this third or fourth sitting, the face is almost finished and the body is largely worked up, but the child's cap and the lower part of the canvas are still to be filled in over the light ground.

Fig. 21
Unfinished Portrait of a Young Girl
*c.*1790
Oil on canvas
56 × 52 cm
Private Collection, courtesy of Patrick Bourne & Co., London

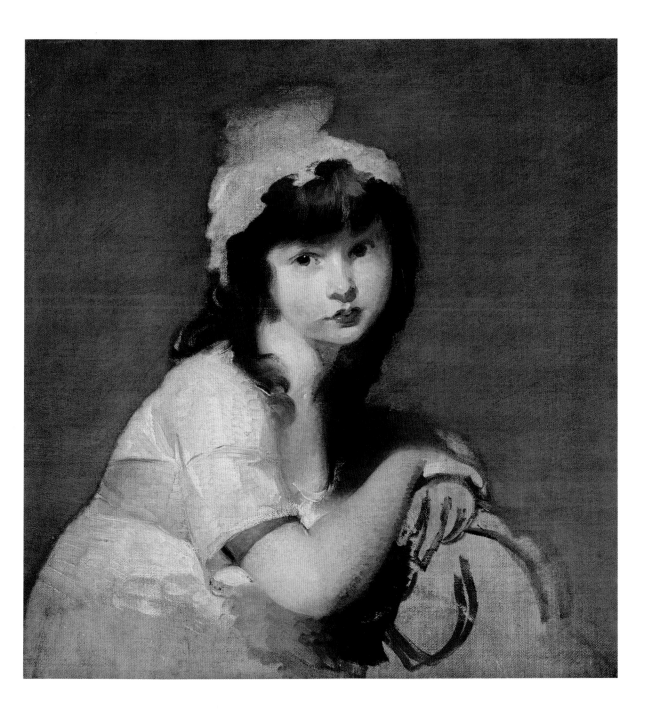

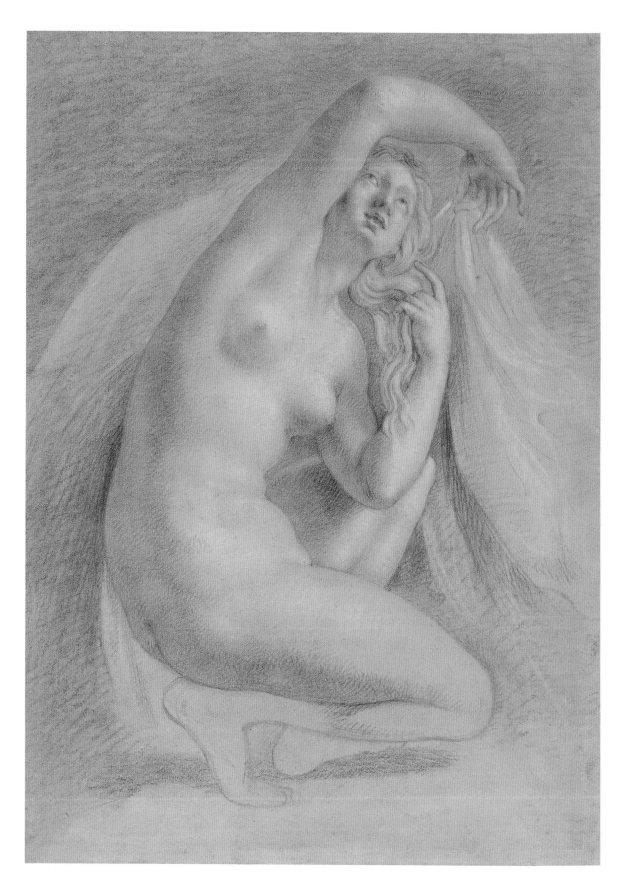

Lawrence contrived his paintings so that they appeared to have been dashed off with ease and panache, but in reality the creative process was never an easy one. The final stage of a Lawrence portrait was the most extravagant: the addition of highlights, scumbles and loose flicks and blobs of texture to create 'an aesthetic of sketchiness or unfinish', an appearance of bravura and spontaneity that concealed the solidity of the structure beneath and the sheer effort that had gone into the finished work.[96]

There was more to being a successful artist than knowing how to handle paint. The best way to improve was by studying the finest work of past artists. At the beginning of 1788 (now living in Jermyn Street with both his parents), Lawrence told Mary Hartley that he was copying a portrait by Titian, but 'going abroad is the centre to which all my aims will ever point: and though perhaps difficult for me to attain, yet shall not the hope forsake me.'[97]

For those who, like Lawrence, could not afford a Grand Tour and first-hand study of the great masters, London offered the Royal Academy, to which he was admitted in September 1787. Lawrence's contemporary, Henry Howard, remembered: 'His proficiency in drawing, even at that time, was such as to leave all his competitors in the antique school far behind him. [...] He excited a great sensation, and seemed, to the admiring students, as nothing less than a young Raphael suddenly dropt among them. He was very handsome; and his chestnut locks flowing on his shoulders, gave him a romantic appearance.'[98]

The Royal Academy, founded in 1768, a few months before Lawrence's birth, was a school run by artists for artists. Its annual summer exhibitions were an important showcase for anyone whose work was accepted for display, held in its purpose-built rooms at Somerset House on the Strand. A student would normally be admitted for six years, starting in the Plaster Academy, where casts of antique sculpture were placed for the tedious but essential process of copying. A drawing of a *Crouching Venus* (fig. 22), perhaps dating from his time at the Antique School, is an early example of Lawrence's transition from graphite or pastel to black and red chalk – a medium that followed in the noble tradition of the Old Masters. This drawing is tinted with red chalk and white

Fig. 22
Crouching Venus
*c.*1789
Black, red and white chalk on paper
34.2 × 24.2 cm
Yale Center for British Art. Gift of Diane Nixon in honour of Lowell Libson

highlights to look like a live, flesh-and-blood model. Lawrence seems to have attended the classes at Somerset House for no more than a few months; he already had too many portrait commissions to allow time for study.

Lawrence continued to make finished chalk drawings, usually of friends, as works in their own right. Combining an informal intimacy with dynamic yet extraordinarily precise drawing, their lively beauty places them among the most captivating works in his repertoire. One of these (fig. 23), exhibited at Lawrence's third Royal Academy exhibition in 1789, would have been recognised by many exhibition-goers as the likeness of Mary Aylward, wife of the newly elected Academician, William Hamilton.

The Hamiltons offered their home in Greek Street, Soho, as an atelier for young artists who 'drew from the antique statues [...] while Mrs Hamilton read to them'; Lawrence became almost one of the family.[99] The portrait demonstrates a delicate balance of delicacy and vigour, while the handling of chalk combines the confident dynamism of rapidly repeated strokes with soft touches of subtle colour. Seated under a canopy-like curtain in her dashing hat, Mrs Hamilton is a matronly figure, but her pale, delicate face and wistful downward glance suggest a childlike fragility.

As Lawrence's ability in oil and chalk grew, he gradually abandoned pastel portraits. His last and best head in crayons appeared at the 1790 exhibition, a sensitive and modest likeness of the elderly classical scholar Elizabeth Carter (fig. 24), a central figure in the Bluestocking circle. Lawrence made this portrait of her aged about seventy-one for her younger friend, his Alfred Street neighbour Harriet Bowdler.[100] During a visit to Bath in 1780, the Bowdler sisters had introduced Carter to like-minded novelist Fanny Burney, who commented: 'I never saw age so graceful in the female sex yet; her whole face seems to beam with goodness, piety, and philanthropy.'[101] This unmarried scholar was trusted as a woman not only of exceptional intellectual powers but also as a sincere and kindly person, equally reliable in domestic matters. It is this combination of the cerebral and the grandmotherly that the young artist has captured so sensitively, using pastel to convey the soft plumpness of her face and the

Fig. 23
Mary Hamilton née Aylward (*c*.1762–1837)
1789
Graphite and red and black chalk on paper
45.8 × 31.2 cm
The British Museum, London

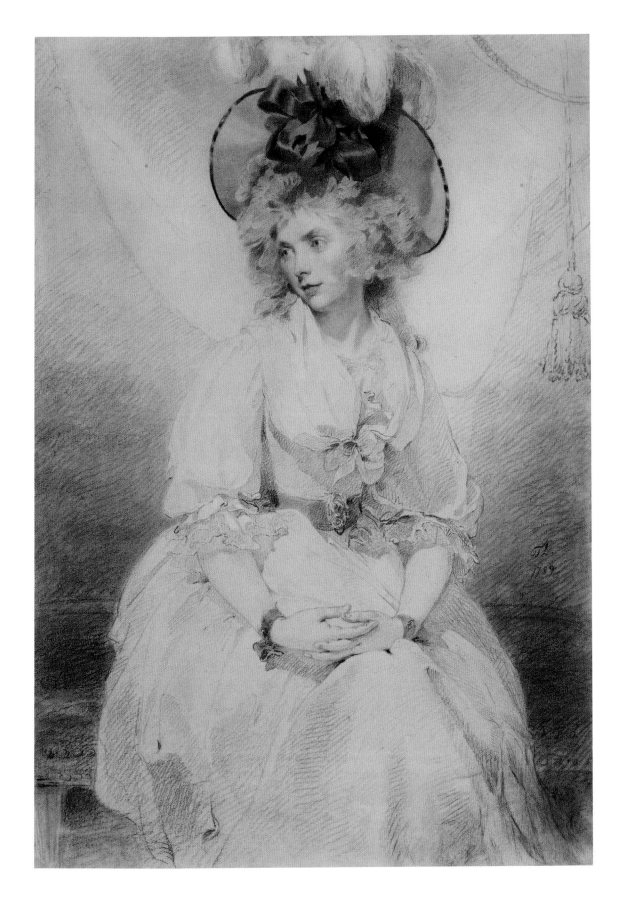

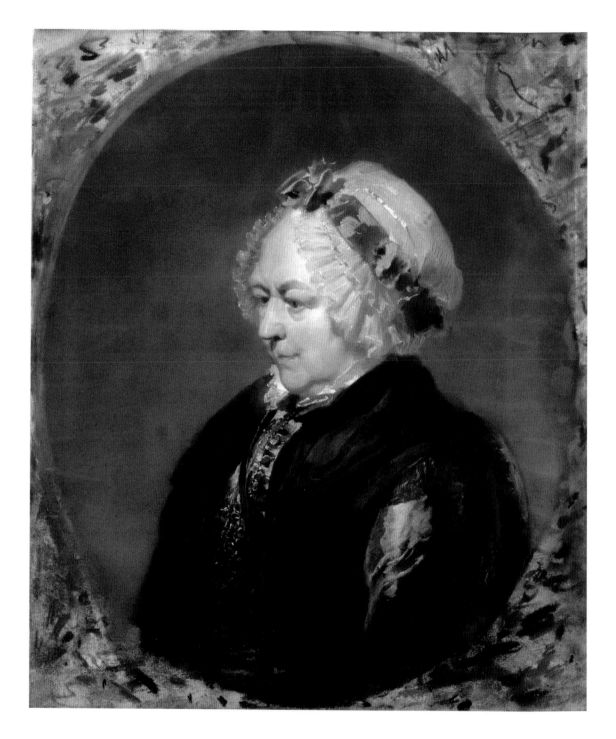

Fig. 24
Elizabeth Carter (1717–1806), 1788–9
Pastel on vellum, 35 × 29.5 cm
National Portrait Gallery, London

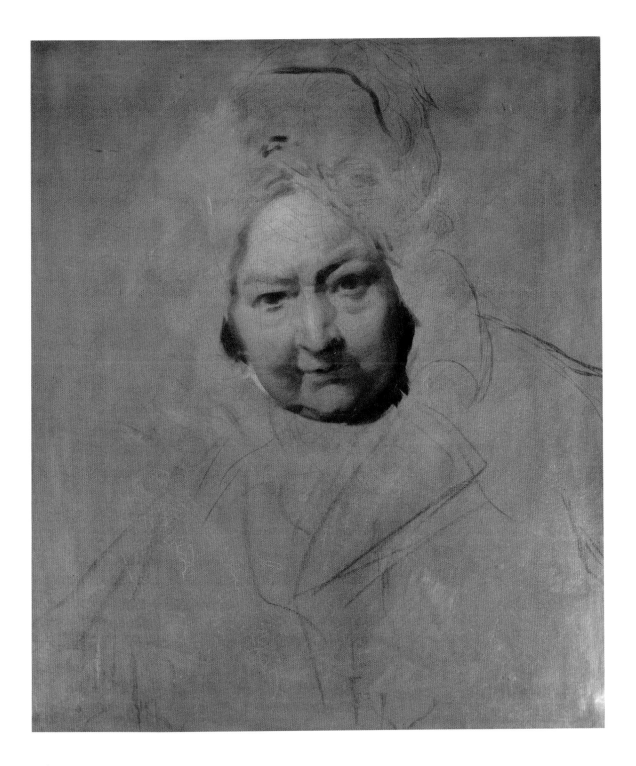

Fig. 25
Head of an Old Lady, possibly Elizabeth Carter, c.1790
Oil on canvas, 58.4 × 50.1 cm
Victoria and Albert Museum, London

elaborately trimmed and starched cap, while her gaze turns inward to higher things.

Carter may also be the subject of an unfinished portrait (fig. 25), begun on a canvas that Lawrence had discarded after the first day of another. The black chalk outline of a young man's head and eyes and the lapels of his coat are clearly visible behind and above the old lady's face. The overlapping of elderly female and young male create an unintentionally haunting effect and an intriguing memento of intergenerational friendship.

Lawrence first gained significant attention from the press at the Royal Academy's 1789 exhibition. In response to the substantial group of oils he showed that year, one critic declared him 'the Sir Joshua of futurity'.[102] Although it is difficult to identify most of the 1789 exhibits from the titles in the catalogue alone, one 'Portrait of a Gentleman' may be his likeness of Thomas Williams (fig. 26). In the late 1780s, this lawyer and Welsh industrial entrepreneur was establishing an estate and copper mills at Bisham in Berkshire, where he built and furnished Temple House as a suitably impressive residence for a parliamentary candidate.[103] Such portraits allowed Lawrence to express contemporary ideals of manliness and explore what it was to be a gentleman – something the artist conveys to striking effect here. Williams's formidable intellect and economic power are expressed in the sturdy body that fills most of the frame, the heavy, clenched hands and unsmiling, bulldog-like features. The contrast of cool grey-blue clouds and swirling scarlet curtain add vitality to the sober colours of the gentleman's outfit.

Visitors to the 1789 exhibition also saw Lawrence's first full-length painting, a portrait of Philadelphia, Viscountess Cremorne (fig. 27) whose husband was said to have been among Lawrence's 'zealous patrons' in Bath.[104] Lady Cremorne was a lady-in-waiting to Queen Charlotte and a close friend of Elizabeth Carter.[105] Whether it was Carter's recommendation or Cremorne's own esteem for the young artist that gained him this commission, it was still a generous offer.

Some of the older women of the Bluestocking circle presented a particular challenge to an artist: bookish and pious, they dressed plainly, depriving painters of the opportunity to flatter them

Fig. 26
Thomas Williams
(1737–1802)
*c.*1788–9
Oil on canvas
127.5 × 102.1 cm
National Museum of
Wales, Cardiff

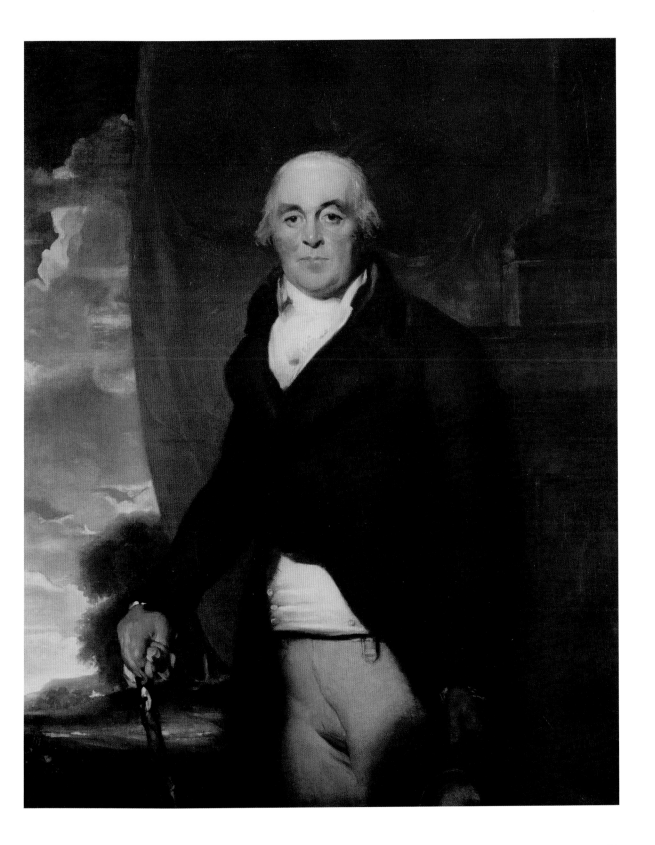

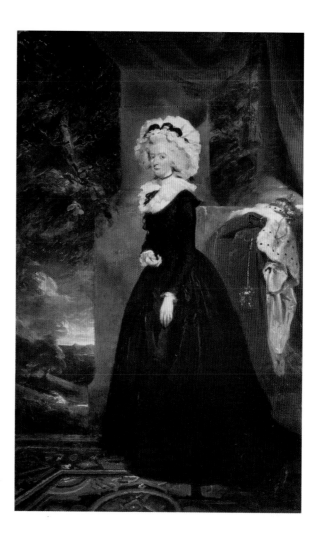

Fig. 27
Philadelphia Hannah,
1st Viscountess Cremorne
(1740–1826)
1789
Oil on canvas
240 × 148 cm
Tate, London.
Presented by the
Patrons of British Art
through the Friends of
the Tate Gallery 1988

Fig. 28
Sarah Trimmer
(1741–1810)
*c.*1790
Oil on canvas
76.2 × 63.5 cm
National Portrait
Gallery, London

with colour and eye-catching lace, satin or jewels. In the case of Sarah Trimmer, a devout Evangelical Christian, her plainness has resulted in one of Lawrence's most original works from the early 1790s (fig. 28). Trimmer's faith made her a champion of education for the poor, founding Sunday schools and a training school for girls. This energetic mother of twelve was about sixty at the time of this portrait and Lawrence has not sought to flatter her by hiding her age. The absence of ornament on the brown bodice is due in part to the picture's unfinished state but the effect, whether intentional or not, is to focus the viewer's attention entirely on the sitter's face surrounded by an amorphous cloud of soft linen.[106] The piercing, bright-eyed and curious gaze creates a formidable yet warm presence.

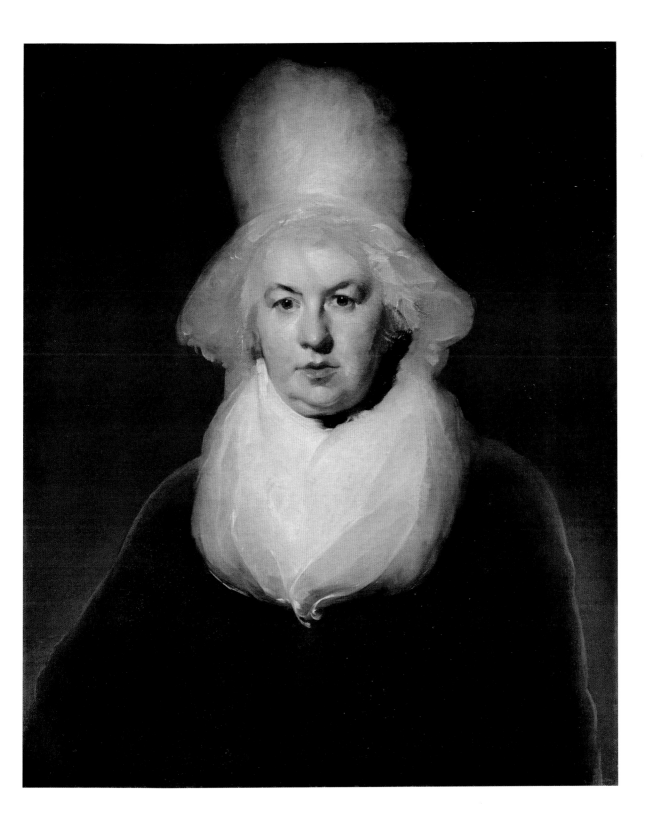

Lawrence's early portraits of older women are remarkable for their sensitivity; they suggest a particular affinity between the artist and his older admirers. His subjects appear modest and serious but full of character: no longer classifiable as 'beauties', they are free to be defined by their achievements rather than their appearance.

One lady who clearly had no difficulty enjoying the most splendid finery was exceptionally wealthy heiress Susanna Archer, Countess of Oxford (fig. 29). Lawrence probably painted her shortly before 1790, when she became a widow.[107] She appears comfortable and confident in her plump flesh and matronly dress, seated under a red damask canopy that contrasts with her blue silk, but the artist's greatest delight is surely in the creamy lines of lace and satin ribbons and the vast diamonds in her ears and cap. The Countess's red lips and bright eyes sparkle as brightly as her jewels and are echoed by the keen eyes, black nose and little red tongue of a terrier, struggling to jump towards the viewer while his mistress stays firmly in her seat.

In September 1789, a letter that read as follows arrived at Lawrence's apartment: 'Sir, I am commanded by Her Majesty to desire you will come down to Windsor and bring your Painting Apparatus with you. Her Majesty wishes you to come down on Sunday next [...] to be ready for Her to sit to you on Monday morning.'[108]

This summons was not entirely unexpected: it was generally understood that his introduction to Her Majesty had been arranged by Lady Cremorne. Queen Charlotte enjoyed encouraging young talent: in 1764 she had welcomed the six-year-old Mozart, and while Lawrence was at Windsor he shared the royal household's attention with the violin virtuoso George Bridgetower, then aged eleven.[109]

If the Queen looks older in Lawrence's portrait (fig. 19) than her forty-five years, it may be because she had recently emerged from what her descendant Elizabeth II would call an *annus horribilis*. The previous summer her happy marriage to George III had been profoundly disturbed by his severe illness, and her relationship with her beloved Prince of Wales irreparably damaged

Fig. 29
Susanna Archer, Countess of Oxford (1728–1804)
*c.*1790
Oil on canvas
127 × 101.6 cm
National Trust for Scotland, Fyvie Castle

by the ensuing political crisis. Not long after the King's recovery, the institution of monarchy itself was violently assaulted in Paris. According to her wardrobe-keeper Mrs Papendiek, she was persuaded to sit to Lawrence that autumn despite believing 'she had not recovered sufficiently from all the trouble and anxiety [...] to give so young an artist a fair chance'.[110]

Technically, this is one of Lawrence's most brilliant works, combining an early tendency to paint in strong, flat blocks of colour with the virtuoso use of liquid paint, applied with breath-taking confidence and vigour. The overall impression is one of serenity, thanks to a thoughtful use of colour and the Queen's dignified yet relaxed pose. Although she has no outward signs of rank, Her Majesty's status is indicated subtly: her seat is placed one step up from the viewer and made throne-like by the heavy drapery hanging like a canopy above her head. Her hair appears as a fluffy cloud around her face, punctuated with tiny black ribbons to create the effect of a halo as she turns a thoughtful, benevolent gaze towards a distant view of Eton College chapel. Whilst being true to the Queen's likeness, Lawrence has contrived, by softening the mouth and enlarging the eyes, to make this notoriously ugly woman almost pretty.

Still only twenty and with no previous experience of royalty, Lawrence had to overcome a considerable level of tension to create a respectful yet convincingly lifelike image of his prickly and sensitive subject. After a first awkward session, the Queen claimed the absence of her Italian hairdresser as an excuse for refusing to organise any further sittings.[111] Lawrence remained at Windsor for over three months until the end of 1789, adding to the network of contacts and friendships that would ensure he was never out of work, and doing his best to make something of the result of the Queen's single sitting.

It was probably the publicity-loving Lawrence senior who in February 1790 advertised viewings of Her Majesty's portrait in Jermyn Street.[112] In April, the artist sent it to Somerset House for his fourth exhibition. The hanging committee were clearly impressed, since all twelve of the works he submitted were accepted. The highlight was his full-length portrait of comic actress

Fig. 30
William Lock of Norbury (1732–1810)
1790
Oil on canvas
76.3 × 63.7 cm
Museum of Fine Arts, Boston. Gift of Denman Waldo Ross as a Memorial to Charles G. Loring

Elizabeth Farren (fig. 40) and the Queen's portrait was declared 'A performance of which VANDYKE would have been proud'.[113]

The 1790 exhibition opened at a time of great excitement in the Lawrence family: not only was Tom's portrait of Her Majesty to be seen by thousands, but he was to celebrate his formal coming of age. In response to those who could not believe the artist was so young, one newspaper published a transcript of his baptismal record, proving that the artist now rivalling Sir Joshua was only on the verge of his twenty-first birthday.[114]

Lawrence senior boasted to his old Devizes patron Dr Kent of his excitement at his son's achievement, concluding: 'Words are wanting to express my sense of gratitude to Heaven and the world for the great name my son has so wonderfully acquired.'[115] Young Thomas now assumed responsibility for his own finances, and the family moved to a rented house in Greek Street, Soho, leaving the Jermyn Street apartment free to serve as the artist's studio.[116] Thomas would continue to pay an allowance from his earnings to the rest of his family. If the artist's father marked his coming of age with a swelling pride, for his mother it seems to have been more of an occasion for anxiety. In a letter dated 4 May 1790, she expresses concern for his material welfare and the 'deranged state' of his financial affairs but above all for his spiritual wellbeing.[117]

Although he continued to live at the same address as his parents, Lawrence found his friends elsewhere. Foremost among them was William Lock, a wealthy connoisseur and collector who had many friends among those that Lawrence had known in Bath. His extended family offered Lawrence relaxation in their country homes, sympathetic ears and, following the deaths in 1797 of both his parents, something approaching a family life, reflected in some of his most beautiful and intimate portraits. They were also generous in offering loans. Lock was related by marriage to the financier, collector and philanthropist John Julius Angerstein, perhaps Lawrence's most lavish supporter. It has been estimated that by 1807, Lawrence owed Angerstein as much as five thousand pounds.[118]

Lawrence's portrait of Lock (fig. 30), said to have been 'hit off at a single sitting', received unfeigned praise in the 1790 exhibition.[119]

Fig. 31
Joseph Farington
(1747–1821)
1794
Oil on canvas
74 × 62 cm
Judges' Lodgings,
Lancaster

68

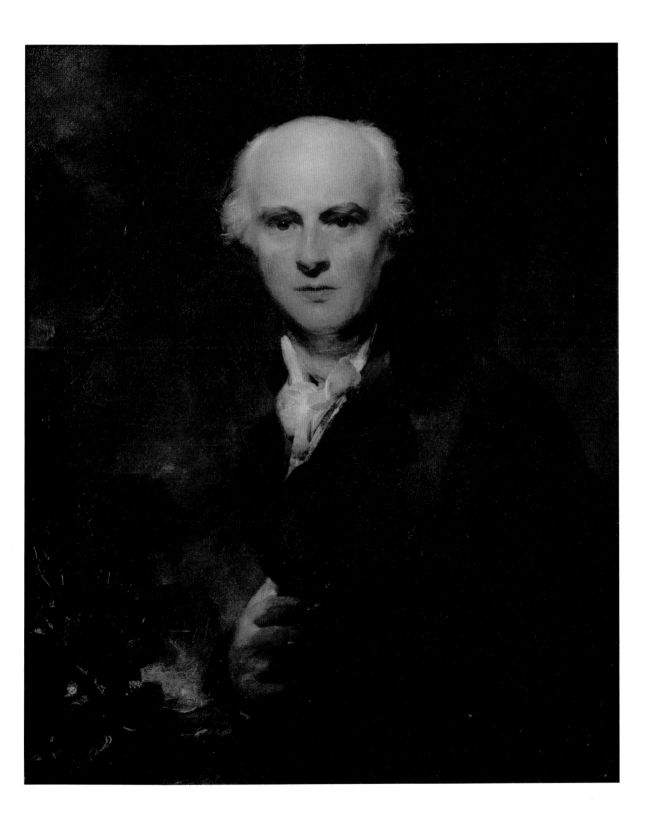

In its unfinished, rapidly sketched state, it has an informality and immediacy that make the sitter tangibly present. Lock is presented as a man of feeling, an austere, grey figure with eyes brightly highlighted in an intense upward gaze. For the *St James's Chronicle*, it was 'a figure expressing the mind of the man'.[120]

Joseph Farington (fig. 31), another generous mentor, was a well-connected artist who thrived in the political atmosphere of the Royal Academy. His diaries are filled with anecdotes and gossip that create a colourful image of Lawrence and his world. Although mainly a landscape painter, Farington was an artist whose opinion Lawrence respected and whose guidance he welcomed. In the mid-1790s he was in his late forties and childless; Lawrence invited him to visit, wearing his blue coat, for a morning's sitting.[121] The directness of Farington's gaze in the resulting picture, made for his beloved wife Susan, and the dramatic landscape setting, are typical of Lawrence's portraits from this period.

One of the most influential figures in Lawrence's first years in London was antiquarian connoisseur Richard Payne Knight, a Herefordshire squire who had inherited an industrial fortune. Lawrence may have become acquainted with him through Knight's friend the Marquess of Abercorn, whose great-uncle Charles Hamilton had encouraged the young artist in Bath, but according to Farington, Knight supported Lawrence to return a favour many years old, 'election services rendered him at Ludlow, by Old Lawrence', presumably around the time he was courting Lucy Read at nearby Tenbury.[122] In his portrait of Knight (fig. 32), Lawrence has used subtle colour and light to make an impressive likeness of a difficult and demanding subject. Like Lock, he is shown looking upwards as though lost in thought, using chunky hands to mark pages in a heavy volume of architectural engravings.

The artist began his only commissioned history painting, *Homer Reciting his Poems* (fig. 33), for Knight in 1788. Narrative compositions based on literary, religious or historical subjects were considered the apex of artistic achievement, but from a business perspective they had little value beyond bolstering the painter's reputation. Lawrence knew that an artist could not be taken entirely seriously without some success in history painting,

Fig. 32
Richard Payne Knight
(1750–1824)
1794
Oil on canvas
127 × 101.5 cm
The Whitworth,
University of
Manchester

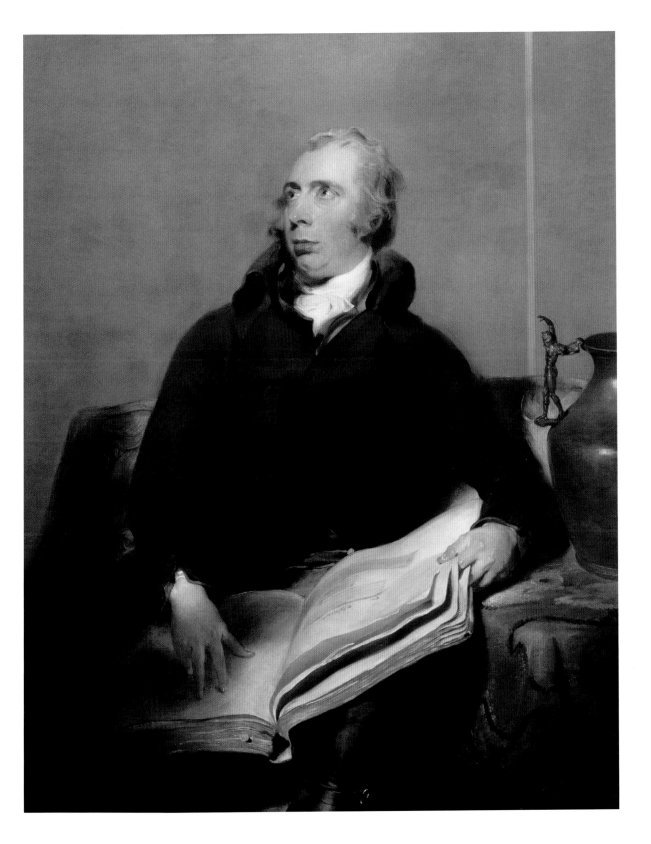

and as the abandoned projects of his Bath period show, he had been constantly frustrated in his attempts, whether through lack of time or lack of confidence.

In 1791, he exhibited the finished *Homer* at the Royal Academy. The scene is a tribute to classical antiquity and Italian Renaissance colouring and chiaroscuro, a catalogue of figure types drawn from the Old Masters and classical sculpture and arranged as a *fête champêtre* in a very English landscape. The artist has borrowed from the past like a magpie: there is clear allusion to Michelangelo in the nude figure in the foreground and the overall composition owes something to the traditional iconography of John the Baptist Preaching.

Behind the varied and sentimental cast of characters, there is one feature of *Homer* that demands to be noticed: the romantic wooded landscape. Many of his portraits from this period contain similar glimpses of glittering water, soaring trees and gloomy sky that tempt the eye away from the sitter, leading the viewer to wonder whether Lawrence might have rivalled his contemporaries as a landscape painter. Although there are occasional references to the artist sketching trees, he was never able to indulge in pure landscape the way Gainsborough did. One exceptional example is a tiny pair of views in Derbyshire, *A View of Dovedale, Looking towards Thorpe Cloud* and *The Source of the Manifold* (*c.*1790–95).[123] The *View of Dovedale* illustrated here (fig. 34) is probably a later copy of one of these.

In interpreting Dovedale's topography, Lawrence has used more artistic licence than many of his contemporaries: the low limestone knoll of Thorpe Cloud has become a towering mountain and the Dove a leaping cataract. The trees are rapidly worked in liquid paint and have a transparent, unreal quality that recalls illuminated glass paintings. It has been suggested that there may be a link between these dreamlike scenes and stage design: Lawrence's passion for the theatre never waned and these little oil sketches may be proposals for an unfinished theatre project.[124]

As he gradually gained independence from his family, Lawrence had to form a public persona for himself, not only as an artist but, more importantly, as a gentleman. As Reynolds, the

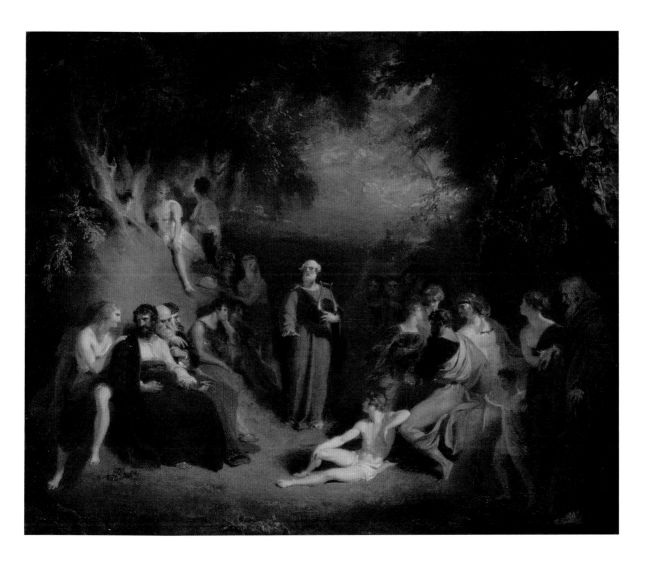

Fig. 33
Homer Reciting his Poems
1790
Oil on canvas
94 × 111.1 cm
Tate, London

Fig. 34
*A View of Dovedale,
Looking towards Thorpe
Cloud*
After *c.*1795
Oil on canvas
43.2 × 67.3 cm
Tabley House
Collection, University
of Manchester

parson's son from rural Devon, had discovered, success in 'face-painting' could lead to a prestige and wealth unattainable to most, but a mastery of polite manners and conversation were crucial for those seeking elite patrons. An artist depended on the work of his hands for a living, yet sought to assume the behaviour, appearance and social life of a gentleman. For many, keeping up a genteel West End establishment that was both home and workshop took most of their income and Lawrence lived in constant danger of overwhelming debt. As he came of age in 1790, Lawrence may have had a very different view of his status from the boastful confidence of his first months in London.

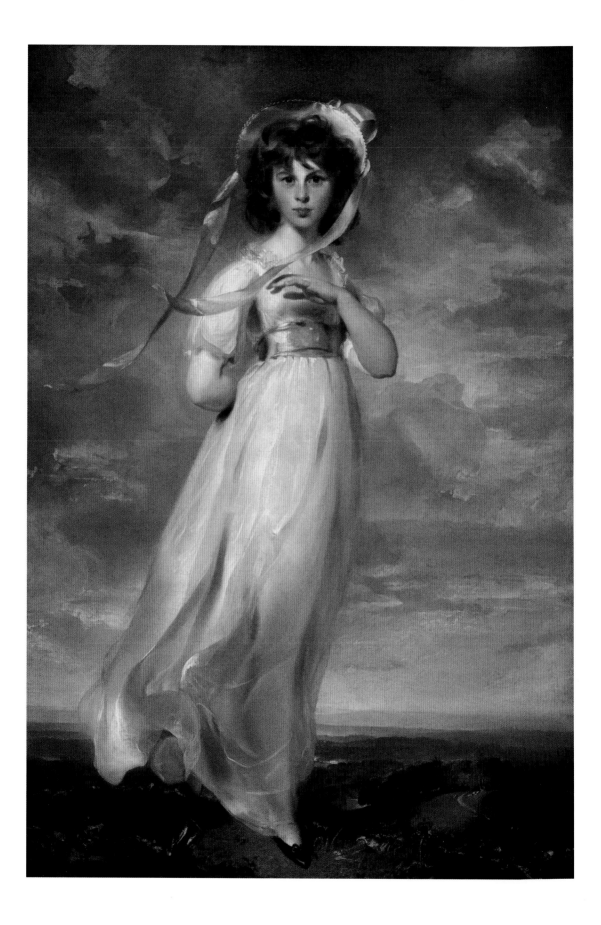

The Most Hazardous Step

Lawrence's twenty-first birthday was only one milestone in a process of growing up that had begun with his baptism in Bristol in 1769. In Devizes, the passage from infancy to boyhood would have been marked by a change of dress from petticoats to breeches, followed shortly by schooldays and the heavy responsibility of paid work. The artist recorded his transition through adolescence in his self-portraits of the 1780s, but at that time seems to have been uninspired by sitters younger than himself: his Bath-period portraits of children are often clumsy and unappealing. As he grew older, he came to capture his young sitters with greater sympathy; during his first seven years in London, Lawrence demonstrated an extraordinary gift for expressing in paint and pencil the unique physical and psychological qualities of the young. His portraits of children, adolescents and young adults have a remarkable power and individuality that fully express 'the human heart in the traits of the countenance', whether that heart is the curious one of a little girl, the complex psyche of a celebrity posing for an audience or the ambitious one of a promising young politician.

The artist would already have learned in Bath that young children, with their soft, mobile features and fidgety bodies, present particular challenges when it comes to portraiture and likeness. Lawrence belonged to the second generation of artists to depict childhood as a condition to be cherished and set apart, and who delighted in emphasising the unique characteristics of the young with an appealing combination of sentiment and honesty. The unfinished painting of a little girl discussed in the previous

Fig. 35
Sarah Goodin Barrett Moulton (1783–1795) 1794
Oil on canvas
148 × 102.2 cm
The Huntington Art Collections, San Marino, California

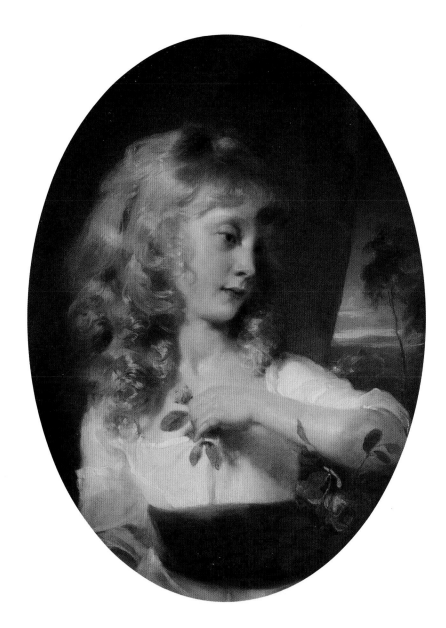

Fig. 36
Princess Amelia
(1783–1810)
1789
Oil on canvas
58.8 × 44.1 cm
Royal Collection Trust,
Her Majesty Queen
Elizabeth II

chapter (fig. 21), which probably dates from around 1790, gives a sense of Lawrence's rapid progress in mastering child portraiture. There is truth and immediacy in the mixture of hesitancy and pertness with which this little girl faces her adult viewer.

Of the artist's twelve works in the 1790 exhibition, five were portraits of children; the one that received most attention was *Princess Amelia* (fig. 36), a likeness of George III's much-loved youngest child, painted at the same time as her mother Queen Charlotte.[125] Here Lawrence already demonstrates some of the hallmarks of his

best portraits of children: extravagantly vivid colours, luxuriant hair and a red, white and pink complexion shaded with blue. The shadow of a ringlet on the princess's cheek is a particularly sensitive detail. Amelia was a brittle-looking child with delicate features and her father's heavy-lidded eyes, but Lawrence has given her solidity and presence by matching the tones of her complexion to a strong blue sash and red curtain, colours recalling his old box of crayons. The six-year-old subject is both a young child and a future woman, with modestly lowered eyes befitting a well-trained young lady and roses that hint at marriage.

During the mid-1790s Lawrence produced two of his most memorable portraits of girls: *Emily de Visme* (fig. 37) and *Sarah Goodin Barrett Moulton* (fig. 35). Both are dressed in white muslin and pink ribbons and set in romantic landscapes, but the contrast between the two, one a smiling little girl and the other an intense adolescent, is striking.

Emily de Visme's exact age is unknown: born on her British father's estate in Portugal, she was brought to England in 1791. Lawrence has imagined the child seated on the ground in a dreamlike woodland, her soft white frock and cheerful ribbons contrasting with the greenish gloom behind her. The girl seems quite unconcerned at her solitude on the fringes of the forest: the implication is that in her innocence she is as much at home in nature as a wildflower. In any case, she is not alone, because, as she raises her bonnet from her eyes, she greets the viewer with friendly curiosity, creating a sense of relationship. Although this pose appears natural and spontaneous, it serves to draw attention both to her face, particularly the eyes, and to the soft roundness of her lower arm.

Like Emily De Visme, Sarah Barrett Moulton (known to her family as 'Pinkie') had recently arrived in London from abroad, travelling from Jamaica in 1792 to attend school. Her grandmother in Jamaica commissioned this full-length portrait as a substitute for the child.[126] Lawrence's image of the eleven-year-old girl is a compelling combination of strength and vulnerability, poised on a tall, column-like body that towers over the landscape, standing up defiantly to the wind that flicks her ribbons away from her chin.

The face she turns towards the viewer does not have the friendly innocence of Emily de Visme – there is something nervous and almost hostile about her staring eyes and flared nostrils. She raises her hand as if to shield her neckline from prying eyes. In its white muslin, her body has a cloud-like lightness and appears ready to float away or dissolve.

In these early portraits of girls, Lawrence follows to some extent a conventional language hinting at the young ladies' future status as brides, such as the association with flourishing vegetation, flowers and the freshness of nature. Young brides were part of the daily fare of face-painters, and a lady's first portrait sitting often commemorated the conclusion of the coming-of-age process in engagement and marriage. For some of Lawrence's female sitters, the road to status in society was less clearly signposted, but they inspired Lawrence to some of his best work. The actress Elizabeth Farren (fig. 40) and the model Emma Hart (née Lyon) (fig. 38) were professional performers, for whom being looked at was their livelihood. Lawrence's full-length exhibition portraits of these two unconventional fiancées represent the culmination of their celebrity and success.

Emma's celebrity as an international figure of dubious repute reached its apex around 1800, when she returned to London from Naples alongside a victorious Lord Nelson. During her 1791 visit to London, when Lawrence painted her, she was already the subject of great curiosity not only as a much-depicted artist's model but also as the mistress, and soon-to-be wife, of Sir William Hamilton, the British Ambassador in Naples. What Lawrence has portrayed is the result of a very conscious effort of chameleon-like transformation from kitchen maid to ambassadress. The artist had longed to meet 'this wonderful woman [...] the most gratifying thing to a painter's eye' and finally had his wish when they were both guests of Richard Payne Knight.[127]

Lawrence's drawing from this time (fig. 39) records not an off-duty moment at the home of a friend but a professional model's self-conscious pose. It relates to the *Attitudes*, a series of tableaux that Emma devised herself, based on the idealised female figures of classical sculpture, in which the only props were a

Fig. 37
Emily de Visme
(1787–1873)
Mid-1790s
Oil on canvas
127 × 101.6 cm
Private Collection

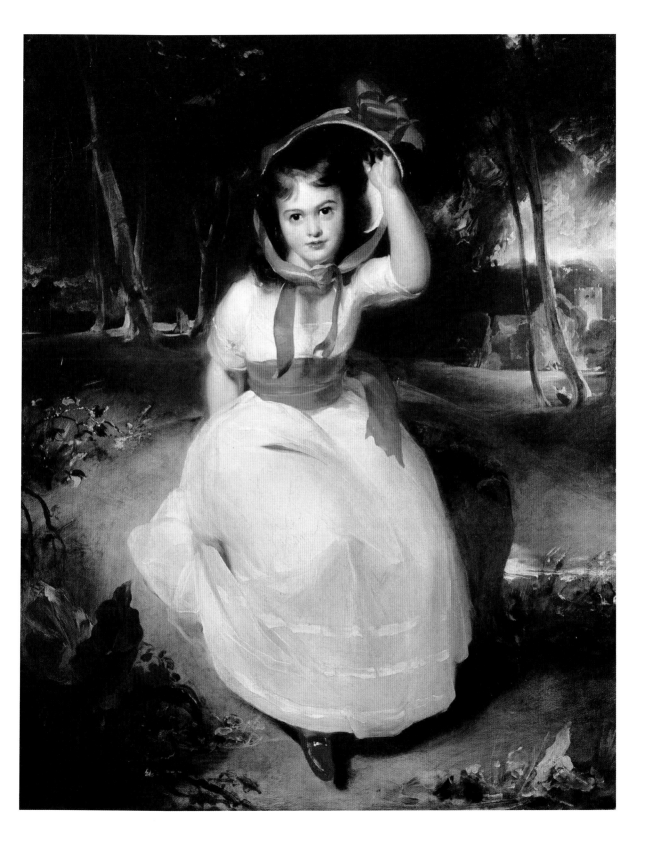

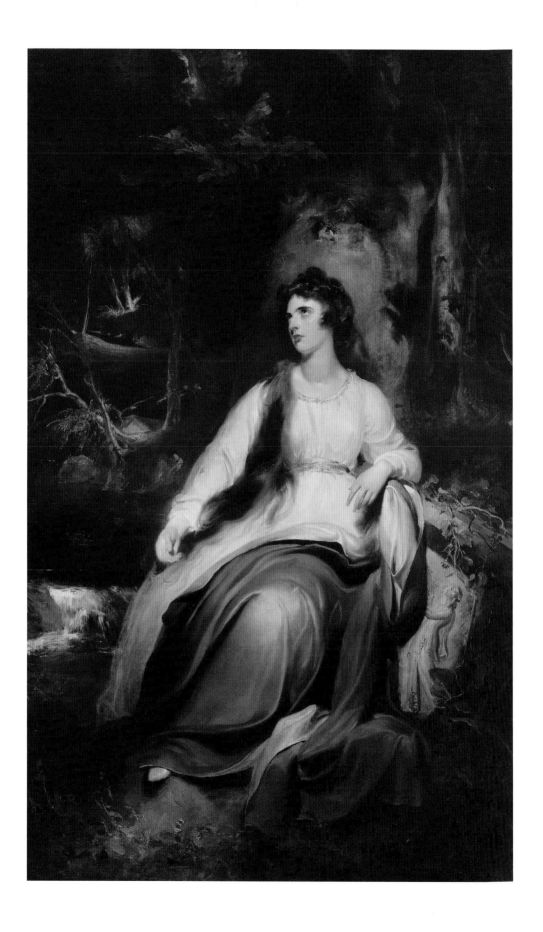

Fig. 38 (opposite)
*'La Penserosa': Emma,
Lady Hamilton*
(1765–1815)
1792
Oil on canvas
243.8 × 152.4 cm
Abercorn Heirlooms
Settlement

Fig. 39 (above)
Emma, Lady Hamilton
1791
Black and red chalk
with stump
19.9 × 15 cm
The British Museum,
London

shawl and her own long hair. As in her performances in Naples, she has twisted a scarf round her head and raises her eyes heavenwards. Emma adopts a similar pose in the extravagant *La Penserosa* (fig. 38), Lawrence's full-length portrait inspired by Milton. She is seated in the darkest and most Gothic of Lawrence's fantasy landscapes, bare headed in the moonlight, her hair tumbling almost to the ground. There is a sense of collaboration between artist and sitter in the arrangement of cloak, hair and body. Lawrence has presented Emma as a pale, emotionally-charged figure entirely

different from the many images that George Romney painted of her in the early 1780s. Romney saw the teenaged Emma as a sunny, blushing and energetic bacchante; Lawrence's soberer view is perhaps more in keeping with her newly respectable, adult status as Lady Hamilton.

Elizabeth Farren had appeared at the 1790 exhibition near Lawrence's portrait of the Queen. Its subject came from a similar background to Lawrence: her father, George Farren, had left his affluent Dublin family for an acting career. Her own fame and success in comedy brought her into the highest society, always chaperoned by her mother, and for many years Elizabeth was effectively engaged to the Earl of Derby. Although around thirty when Lawrence painted her, his portrait is a celebration of youthful freshness and energy that uses coded messages to emphasise her nubile state. According to the decorum of the time, married ladies would never go out hatless, and the actress is portrayed bare headed, wearing the sort of white muslin frock that had once been reserved for children but was now fashionable for young women. As with Pinkie's after her, the actress's height and slender figure are emphasised by a low viewpoint and a backcloth of sunlit clouds. Lawrence has tinted her face and lips with the fresh red and pink colouring of a teenager. Only her deliciously luxurious accessories identify her as a society lady; indeed, when the catalogue for the 1790 exhibition appeared, Miss Farren complained to Lawrence that her portrait had been listed as 'An Actress' rather than 'A Lady'.[128]

The eighteenth century had seen much discussion of growing up and what defined an adult, a child and any of the stages in between, particularly where boys were concerned. Educationalists sought to identify the qualities that constituted a gentleman, and how a boy might safely make the transition to manhood through what, according to John Locke, was 'the most hazardous step in the whole course of Life'.[129] Then as now, adolescence was not clearly defined but in boys corresponded roughly to the ages of fourteen to twenty-one, followed by 'youth', which might continue until the age of thirty.[130] It was by its nature an age of anxiety, for the boy facing physical and emotional changes and all the dangers and

Fig. 40
Elizabeth Farren,
later Countess of Derby
(*c*.1759–1829)
1790
Oil on canvas
238.8 × 146.1 cm
Metropolitan Museum
of Art, New York

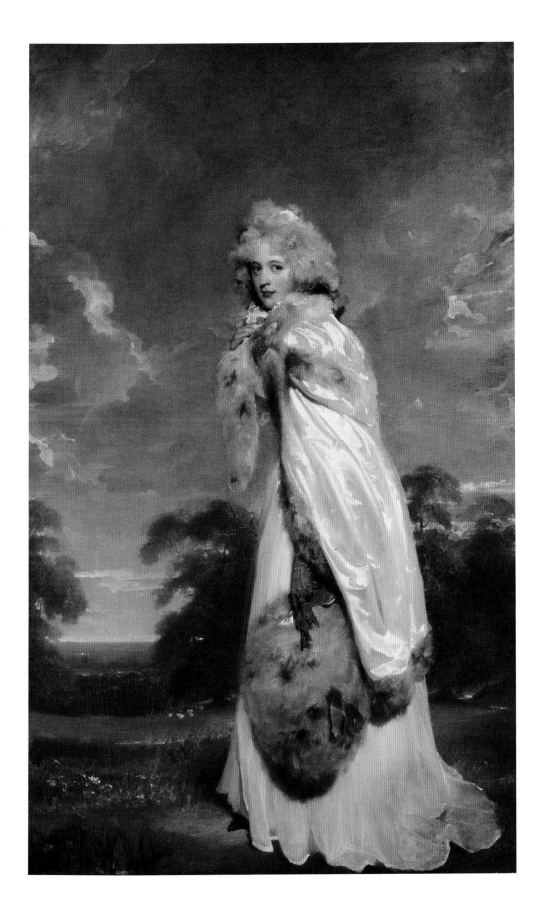

responsibilities of adulthood, and for the adults concerned with taming the unruly and guiding him through the temptations of youth. In his portraits of young men, Lawrence helps his sitters to complete the process – begun in childhood – of becoming moulded into the conventional model of a gentleman. If, as has been suggested, Lawrence's portraits of children and families were a response to his own unconventional boyhood, it is in his sympathetic and perceptive images of adolescent boys and young men that the artist comes closest to expressing his own private experience of coming of age, with all its contradictions.[131]

His portrait of the youngest of the Linley children, William (fig. 41), was exhibited in 1789 shortly before the young musician's departure for civil service in the East India Company. His family turned to their old Bath friend, William's contemporary Tom Lawrence, for a likeness to remember their son by. The composition is a sombre one for a boy still in his teens: if Linley's dark coat is the uniform of a scholar at St Paul's school (where he had been a pupil since February 1785), then it has prompted another exercise in the manner of Rembrandt.[132] There is nothing in the costume to distract the eye from the sitter's brightly lit features, which the viewer is invited to study and scrutinise. Linley is neither fully a child nor fully an adult: his hair is still cut in the glossy fringe of a schoolboy, but it hangs low over luxuriant eyebrows. An almost transparent wisp of hair escapes across his pink cheek, as though stressing the absence, or anticipating the presence, of facial hair. The undulating movement of the hair is taken up by the faster, less orderly rhythm of messy white squiggles at the heart of the composition, an artfully crumpled neck-cloth that compels the eye to explore its web-like folds as though probing the young man's inner thoughts.

About two years after William Linley sat to him, Lawrence was asked to paint another school-leaver, this time from Eton College. His portrait of Arthur Atherley exists in two versions, an unfinished head-and-shoulders (fig. 42) and a striking three-quarter-length exhibition piece (fig. 43) exhibited at the Royal Academy in 1792. A comparison between the two shows how Lawrence used the same likeness of an adolescent to create very

Fig. 41
William Linley
(1771–1835)
1789
Oil on canvas
76.2 × 63.5 cm
Dulwich Picture
Gallery, London

Fig. 42
Unfinished Portrait of Arthur Atherley
(1772–1844)
1791
Oil on canvas
62.2 × 50.8 cm
The Holburne Museum, Bath

Fig. 43
Portrait of Arthur Atherley as an Etonian
1791–2
Oil on canvas
125.7 × 100.3 cm
Los Angeles County Museum of Art, Los Angeles

different impressions: one of intimacy and innocence, the other of distance and worldliness.

When Lawrence began the portrait of Atherley in 1791, his sitter was only two, perhaps three, years younger than him. The unfinished, apparently abandoned, canvas shows the first stage in the process of composition, placing the head in the canvas and experimenting with colour; the pale ground still holds traces of Lawrence's initial drawing. If finished, this portrait may have been similar to William Linley's but enlivened by a blue coat and the sitter's high colouring; Atherley is flushed, as though he has just come indoors from a game of cricket. Lawrence has placed one of his sitter's eyes in the deep shade of his fringe; on the brighter side of his face, a little curl drops down to meet the point of the boy's eyebrow, drawing the viewer's gaze straight into his. The difference

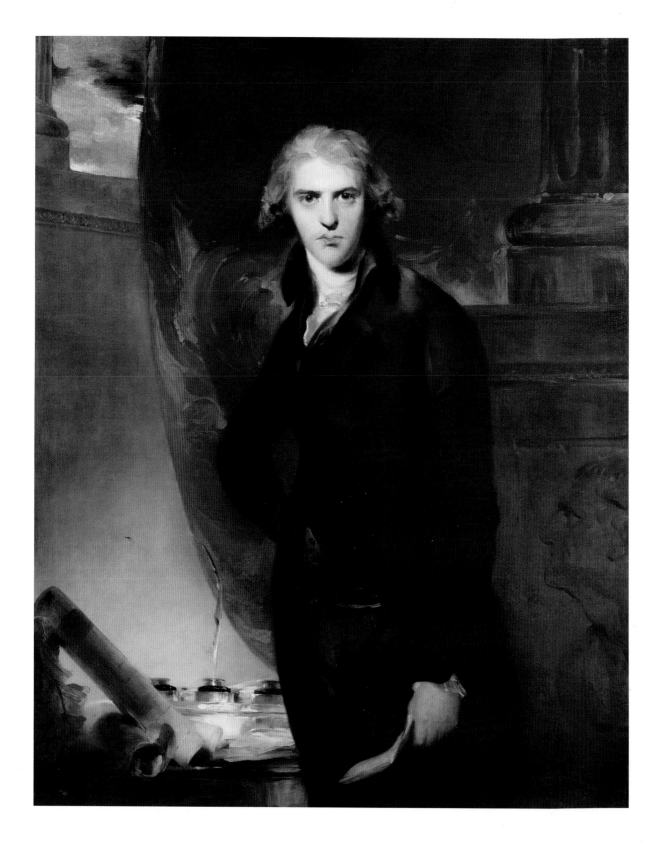

between the two eyes, one concealed and one shining brightly, communicates a mind caught between confidence and anxiety in a body hovering uneasily between childhood and maturity.

The finished portrait lacks the immediacy of the artist's first thoughts, but makes up for them in its power. Through simple changes in composition and colour, Lawrence transformed the half-formed schoolboy into an impressive young man. The format has been extended to include the body as far as the knees, striding through a landscape whose low horizon allows Atherley to tower above the meadows of Eton. For Atherley's pose, Lawrence turned to two standard models for young men: the *Apollo Belvedere*, considered since the Renaissance the canon for the ideal young male body, and the full-length portraits of Van Dyck, from which the hand on the hip, long curling hair and low viewpoint are all borrowed. The face is an almost exact copy of the unfinished version, but minute alterations to the arch of the brow and curl of the lip have relieved it of any appearance of anxiety. Perhaps the most effective change has been in the choice of colours: the coat is now a rich red whose assertive colour breathes vitality into the whole portrait, designed for maximum impact on the overcrowded walls of the Great Room at Somerset House. Atherley's martial-looking red coat is a demand for attention, calling the viewer to pause and engage with the half-friendly, half-adversarial gaze of an ambitious young person. With his height, immaculate outfit and assertive glare, Atherley looks more than equipped to survive the chaos and violence of an eighteenth-century public school.

The formula developed for Arthur Atherley is one Lawrence returned to for many other paintings of young men. For his first portrait of Robert Banks Jenkinson (fig. 44), the future Prime Minister Lord Liverpool, he chose an even lower viewpoint, placing the head very near the top of the canvas and lighting it from above to emphasise his sitter's above-average height and intellectual authority. The young politician's seriousness and drive are underscored by his sober dress in several shades of black, set off by a scarlet curtain woven with dancing plumes of impasto. The still life of papers and silver inkstand indicates Jenkinson's responsibility as a junior minister. With his direct but unsmiling

Fig. 44
Robert Banks Jenkinson, later 2nd Earl of Liverpool (1770–1828)
1793–6
Oil on canvas
127 × 101.6 cm
National Portrait Gallery, London

gaze and somewhat weakly foreshortened right arm, the sitter conveys a disconcerting combination of strength and unease; the portrait reflects both Jenkinson's hard-line approach to politics and his personal diffidence.[133]

As a counterpart to the loud swagger of Atherley or Jenkinson, Lawrence was also producing quieter, smaller-scale and more intimate portraits of young men. There are psychologically penetrating drawings from this period of such friends as Richard Westall, William Godwin and the younger William Lock.[134] Around 1794 the artist made an oil portrait of Samuel Rose (fig. 45), the barrister who introduced Lawrence to poet William Cowper.[135] It uses a similar technique to *Arthur Atherley* in half-obscuring one eye so that the other can claim the viewer's full attention.

Lawrence's portraits of young men are the product of an artistic world of male artists, critics and patrons. An artist's training was founded on drawing the male figure, whether from life or mediated in copies after the antique and Old Masters. During the last two decades of the eighteenth century, the walls of the Royal Academy were dominated by images of heroic masculinity, both in portraits and history paintings.

In about 1794, Lawrence began to bring to maturity an idea that he hoped would be so colossal and sublime that it would secure his reputation as more than a mere face-painter. When John Sherwin published the boy's portrait reading *Paradise Lost* (fig. 2), the beginnings of *Satan Summoning his Legions* (fig. 46) were already fermenting in Lawrence's mind. Interest in Milton had been revived by new editions of his epic verse and, as the French Revolution roused debate in Britain on the virtues and dangers of rebellion, the arts responded with a sort of Milton-mania.[136] In Milton's imagination, Satan had been the most beautiful of God's angels, and his persistent but ultimately futile rebellion against the Creator is seen as an act of fatally flawed anti-heroism. As Satan justifies himself by disguising his evil motives and actions as good ones, so his outward appearance is bright and beautiful, hiding the true nature of the 'infernal serpent'.[137]

Several drawings exist, probably from the mid-1790s, in which Lawrence imagines the figure of Satan and works out his

Fig. 45
Samuel Rose
(1767–1804)
*c.*1794
Oil on canvas
76 × 63.5 cm
Courtesy of Bagshawe
Fine Art

composition for the final oil painting on an epic scale.[138] The pencil drawing illustrated here (fig. 47) uses a low viewpoint and assertively powerful pose. The most finished area is Satan's head: it closely follows Milton's description of a face marked with 'Deep scars of Thunder'.[139] The aggressive glare from under a helmet ornamented with wriggling snakes recalls the windswept curls and bold stare of Pinkie, but the arms are raised to expose a fearless body. The elegant arrangement of unashamedly naked legs, which appears to have been taken straight from a dancing-master's manual, has been replaced in the final painting (fig. 46) with a much more aggressive stance, the legs planted firmly apart.

When Lawrence wrote from Bath about a scene from Milton that he was composing, inspired by Michelangelo, he reported altering Satan's face from 'an expression of horror' to 'one with more Majesty & Bearing'.[140] In his oil painting of ten years later, the horror has returned. The classical hero's face of his pencil drawing has evolved to take on a bestial quality as Satan, cast into the fiery lake of Hell, calls on his followers to renew their attack: 'Awake, arise, or be for ever fallen!'[141]

Reactions to *Satan* at the 1797 exhibition were understandably mixed; the similarity to the work of Lawrence's friend Henry Fuseli, then working on a *Milton Gallery*, did not go unnoticed. For one gleefully vicious critic 'it convey[ed] an idea of a mad German sugar baker, dancing naked in a conflagration of his own treacle!'[142] Westall later confided to Farington that he 'did not think Lawrence qualified to paint Historical subjects. He has little of the creative power.'[143]

Fig. 46 (opposite)
Satan Summoning his Legions
1796–7
Oil on canvas
431.8 × 274.3 cm
Royal Academy of Arts, London

Fig. 47 (above)
Preparatory drawing for 'Satan Summoning his Legions'
c.1796–7
Pencil on wove paper
32.5 × 19.3 cm
Royal Academy of Arts, London

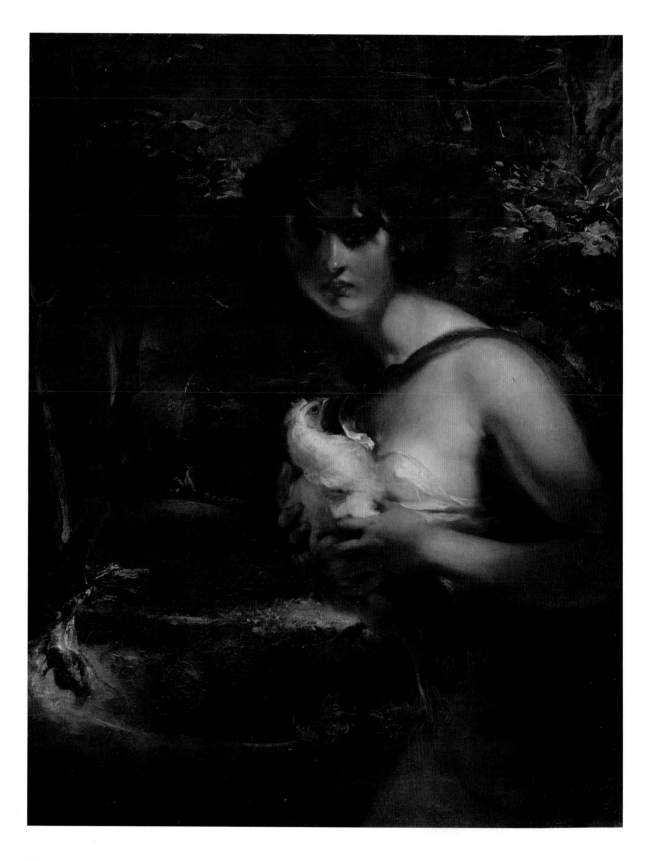

THE MOST HAZARDOUS STEP

Something of the same disobedient spirit inhabits the painting Lawrence submitted to the Royal Academy to mark his election to full membership at the age of twenty-five. By the standards of his time, Lawrence's relative youth was by now no longer remarkable: he was one of many gifted young artists vying for work in London. In a crowded and highly competitive market, reputation was everything; the magic letters 'RA' after an artist's name were a mark of excellence that allowed them to be considered members of an elite.

Although keen to receive his diploma, Lawrence was less assiduous about carrying out the task required by the Academy: to provide an example of his work for their collection. According to an unwritten rule, portraits were not acceptable.[144] Lawrence has therefore opted for an imaginary subject that uses the format of a half-length portrait, *A Gipsy Girl* (fig. 48). As a sample of his work, it demonstrates his extraordinarily skilled and novel use of paint, his delight in romantic, dreamlike forests and his gift for combining character and beauty in the same figure. His narrative of a wild, brown-skinned young girl bearing away a plump chicken draws on his successes portraying adolescence in boys and girls to depict all the energy and ambiguity of youth. Just as this boldly erotic figure is both child and adult, she could be seen equally as a criminal or a scapegoat: the wide-eyed white hen clutched to her breast, innocent victim of a dishonest thief, is about to become a well-earned supper for a family suffering in an increasingly unjust rural Britain. There is further ambiguity in the tiny, stylised figures emerging from the woodland shadows: a tall, well-built young man followed by a young female and an infant – are they the gipsy's own siblings excitedly gesturing towards their successful hunter-gatherer, or honest cottagers chasing a dangerous intruder? *A Gipsy Girl* could be a metaphor for Lawrence's own achievement, brazenly snatching status and accolades from under the noses of more established but less talented artists.

Fig. 48
A Gipsy Girl
1794
Oil on canvas
91.5 × 71.1 cm
Royal Academy of Arts,
London

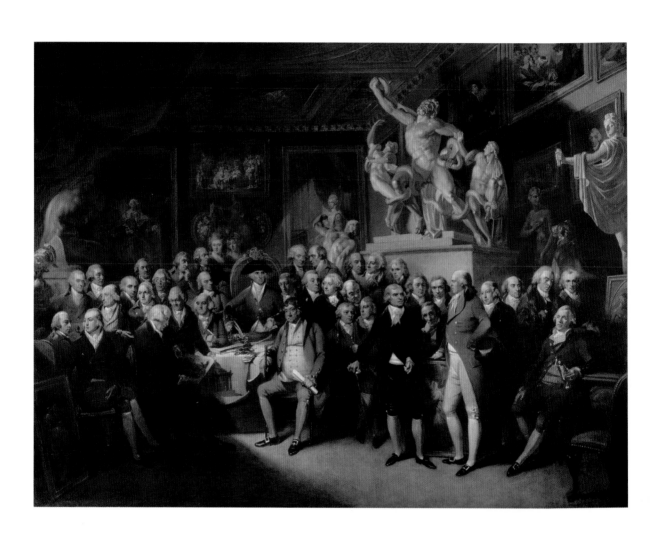

Gleams of Power

In 1795, Henry Singleton composed a group portrait of all the members of the Royal Academy (fig. 49). The margins of the crowd are dominated by reproductions of the most admired antique sculptures; compared to these paragons of beauty, the middle-aged, middle-class academicians look shabby and tired. On the far left of the image one artist stands out for his neatness of appearance, like a butterfly that has floated into the wrong room from the pages of a fashion magazine. The pointed pumps, slender striped breeches and dashing spotted waistcoat belong to Thomas Lawrence, imagined by Singleton at his first General Assembly. This delicate young man is still recognisably the same wide-eyed boy who drew himself in pastel in Bath, but that famous chestnut hair is beginning to recede. His twisted seated pose echoes that of the huge cast of the *Belvedere Torso* directly above him: comparison with this heavily muscular form makes the artist appear fragile and insubstantial among his older, more self-possessed peers.

Reading between the lines of his correspondence and contemporary gossip, Lawrence's uncomfortably dapper outfit is not so much a sign of vanity as the dress of someone too anxious to please, painfully aware of his celebrity and the need to keep up appearances. There are many complaints about his overly formal manners, the pleasing performance that he had kept up since childhood now losing its charm to coldness. In his anxiety to distance himself from the manners of the Devizes taproom, he had become a 'perfect Gentlem[an …] controlling every feeling that is incompatible with breeding'. [145]

Fig. 49
Henry Singleton
(1766–1839)
*The Royal Academicians
in General Assembly*
1795
Oil on canvas
198.1 × 259 cm
Royal Academy of Arts,
London

Lawrence was coming to realise that his unconventional upbringing had laid the foundations for his struggles in adult life as well as his success. His unofficial and permanent appointment as the family's main breadwinner from the age of eleven placed him under exceptional pressure but also gave him extraordinary privileges. He always regretted his lack of formal education: his ignorance of traditional classical learning condemned him to be an outsider among gentlemen, but it was the absence of practical professional knowledge that most affected him. Writing to his nephew in 1821, he wished his parents had given 'their son, whom they so truly loved, two or three parts in education of the utmost importance to the future happiness of the man' since '[t]here cannot be a more essential good, or, probable security against evil, in the education of a young man than his being made a good accountant.'[146] As an adult, Lawrence was never free from serious debt and financial worries, and his family continued to expect regular contributions from him.

The sudden death of both his parents in 1797, Lucy in May and Thomas in November, left Lawrence both relieved and alone. The letters he wrote to Sophia Lee reporting his loss reveal his affection and concern for both mother and father; the suddenness of their departure was clearly a shock.[147] Shortly before her death, the artist captured Lucy's likeness in a chalk drawing (fig. 50) that reveals the remnants of his mother's beauty in her weary features. Her husband had, at worst, been a stubborn, demanding and unsympathetic father; at best, he did everything in his power to encourage and celebrate his son's talents, and to support all his children equally, regardless of their earning power. A few months before his father's death, Lawrence wrote of his 'essentially worthy nature', but that 'to be the entire happiness of his children is perhaps the lot of no parent'.[148]

The artist's home in Greek Street was suddenly empty. Anne had married clergyman Richard Bloxam in 1790 and moved to the Midlands and their elder sister Lucy married soon after their parents died. Over the following months, Lawrence was engaged first to Sally and then to Maria, the daughters of William and Sarah Siddons. Maria was seriously ill with consumption and

Fig. 50
The Artist's Mother, Lucy Lawrence (d. 1797)
*c.*1796
Graphite and coloured chalks on paper
23 × 19 cm
Private Collection, UK
c/o Lowell Libson & Jonny Yarker Ltd

on her deathbed she made Sally promise never to see Lawrence again. The confidential correspondence about this episode reveals a painfully messy drama in which Lawrence acted with disturbing immaturity. As he approached thirty, John Bernard's ten-year-old 'perfect man in miniature' had become, to Bernard's colleague Sarah Siddons, a 'wretched madman'.[149] By 1800, his situation had reached its lowest point: in the Academy, there were very public squabbles with rival John Hoppner, and his debts were bringing him to the verge of bankruptcy.[150] However, in the words of younger artist Benjamin Robert Haydon, 'weakened and harassed as Lawrence was by the habits of society, there were always gleams of power about him.'[151]

With help from his friends, and by taking on pupils, Lawrence's situation gradually improved. At the end of 1813 his finances were secure enough to allow him to take on a grand townhouse in Russell Square. The real change in his fortunes came the following year, when he finally met Queen Charlotte's artistically discerning and extravagant eldest son, the Prince Regent. For the next fifteen years Lawrence was be 'to the Regent and King, George IV, what Holbein was to the Court of Henry VIII, and Van Dyck to that of Charles I'.[152] Almost immediately, the Prince awarded Lawrence a knighthood and began to commission a series of portraits on a grand scale that mark the culmination of the artist's career. His twenty-eight full-lengths depict the heads of state and military leaders of the European alliance that defeated Napoleon in 1814 and negotiated peace the following year. On vast canvases over two and a half metres high, the series was destined to hang in a purpose-built gallery at Windsor Castle, the Waterloo Chamber. Lawrence painted these illustrious international sitters in London, Aix-la-Chapelle, Vienna and, finally, Rome.

The Prince sent Sir Thomas to Rome to paint his ally Pope Pius VII (fig. 51), but Lawrence was conscious that, in painting a pope, he was trespassing on the territory of Raphael, Diego Velázquez and other giants; he arrived in Rome in the greatest anxiety. Three months later, he wrote to his sister Anne: 'I am happy to tell you, that I have completely succeeded in the picture of his Holiness,

and to the utmost of my expectation [...] I think it now the most interesting and best head that I have painted.'[153]

As soon as he began his nine sittings with the Pope, Lawrence was impressed by his 'good and cheerful nature' and deeply touched by his affectionate and fatherly welcome.[154] The old man's body, swathed in a cosy fur-lined mozzetta and matching velvet slippers, looks frail against the large throne and grandiose setting, worn down by his imprisonment in 1809, but not broken, an embodiment of the benevolent force that helped unite Europe after two decades of war. Lawrence's Pope is presented not only as a peacemaker but also as the keeper of one of the world's most magnificent art collections, recently recovered with British help. His serenely wizened figure is contrasted almost humorously with the writhing bodies of the *Laocoon* and the perfection of the *Apollo Belvedere*.

Pius VII represents a vindication of all the aspirations contained in Lawrence's earliest self-portraits. As a boy, he had presented himself as an heir of Raphael but was denied the opportunity to see the great master's work in Rome and had to make do with copies supplied by local well-wishers. In his late forties, he finally fulfilled the frustrated hope of 'going abroad' that he had expressed to Mary Hartley in 1788. In the Sistine Chapel, he was 'silent and awestruck' in the real presence of those familiar figures by Michelangelo that had so impressed him as a boy.[155]

In Devizes, the Lawrences had been uniquely placed to gain the attention of influential and well-disposed visitors to Bath, particularly the charmed circle that revolved around Garrick, Johnson and Reynolds. In Alfred Street, their Bluestocking neighbours eventually led the young artist to his residency at Windsor with the Royal Household and friendships with such discerning and generous mentors as William Lock. At the Theatre Royal, they befriended actors and musicians who would provide Lawrence with such celebrity sitters as Sarah Siddons and Elizabeth Farren. The encounter with Georgiana, Duchess of Devonshire, in Bath eventually oiled the wheels that made Lawrence such a welcome guest of the Pope. In Bath, Georgiana had met not only Lawrence but also a penniless Lady Elizabeth Foster, soon to

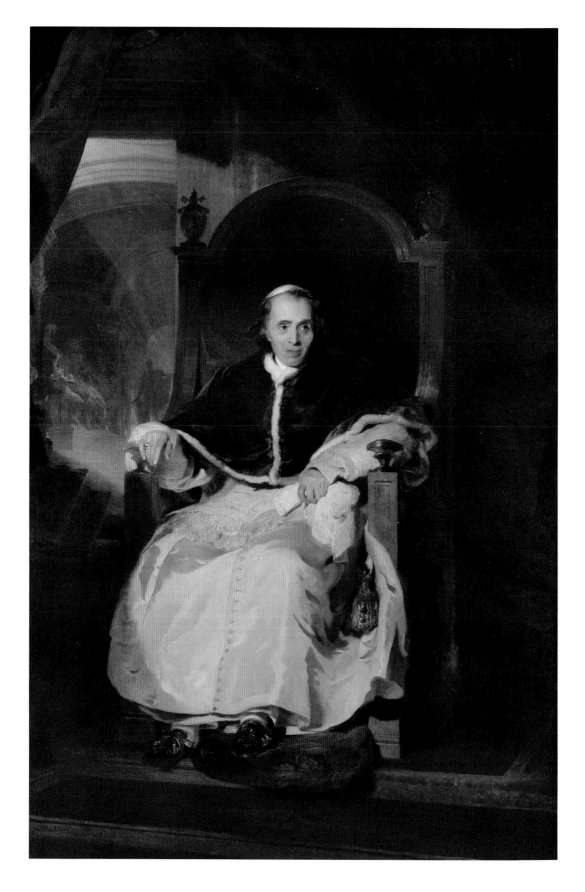

become her 'dearest friend' and her husband's mistress. Following Georgiana's death, Elizabeth, now Duchess of Devonshire herself, retired to Rome. It was her closest friend Cardinal Consalvi, the Pope's Secretary of State, who welcomed Lawrence to a luxurious apartment in the Quirinale Palace in 1819.

As Michael Levey has observed, the Waterloo Chamber portraits allowed Lawrence to excel as a history painter, not by composing imaginary narratives but by commemorating the momentous events of his own time in portraits of their main protagonists. Pius VII's warm reception of Lawrence as envoy of the British sovereign marked a milestone in diplomatic relations that had been severed for much of the past three hundred years.

The Waterloo portraits and his travels abroad helped gain Lawrence an international reputation. After exhibiting at the Paris Salon in 1824, he was appointed to the Légion d'Honneur. On his return from Rome in 1820, Lawrence found that Benjamin West (1738–1820), the long-serving President of the Royal Academy, had died. Sir Thomas, now fifty, his confidence fortified by the success of the Pope's portrait, was elected in West's place. It was as though he had finally come of age.

Fig. 51
Pope Pius VII
(1742–1823)
1819
Oil on canvas
266.8 × 173 cm
Royal Collection Trust,
Her Majesty Queen
Elizabeth II

Notes

1 Frances Burney, ed. W.C. Ward, *Diary and Letters of Madame D'Arblay*. London: Henry Colburn, 1854, vol. 1, pp. 262–3.

2 Graphische Sammlung Albertina, Vienna; Kunsthistorisches Museum, Vienna.

3 D.E. Williams, *Life and Correspondence of Sir Thomas Lawrence*. London: Henry Colburn and Richard Bentley, 1831, vol. 1, p. 99.

4 *Bath Chronicle*, 30 November 1780, p. 3.

5 Williams, vol. 1, pp. 19–20.

6 Douglas Goldring, *Regency Portrait Painter: The Life of Sir Thomas Lawrence, PRA*. London: Macdonald, 1951, p. 18; Williams, vol. 1, p. 18.

7 Williams, vol. 1, pp. 34–5.

8 T.B. Smith, 'On the Early Life of Sir Thomas Lawrence, PRA', in *Wiltshire Archaeological and Natural History Society Magazine*, IX (1866), 194–205, p. 196.

9 Williams, vol. 1, p. 36; Goldring, pp. 28–9; *Bath Chronicle*, 15 September 1774, p. 1.

10 *Sketchley's Bristol Directory*. Bristol, 1775, p. 54; Williams, vol. 1, p. 43.

11 Michael Levey, *Sir Thomas Lawrence*. New Haven, CT, and London: Yale University Press, 2005, pp. 30, 34.

12 Goldring, p. 28.

13 Burney, p. 262.

14 *Bath Chronicle*, 22 June 1780, p. 2.

15 Trevor Fawcett, *Bath Entertain'd*. Bath: Ruton, 1998, p. 82.

16 John Bernard, *Retrospections of The Stage*. London: Colburn and Bentley, 1830, vol. 2, p. 81.

17 Williams, vol. 1, pp. 53–4.

18 Susan Sloman and Andrew Wyld, 'The Actor Thomas Grist: A Portrait by Lawrence', *The British Art Journal*, 2.1 (2000), 81–2.

19 Smith, p. 195.

20 Burney, p. 263.

21 Smith, p. 199; Goldring, p. 38.

22 Kenneth Garlick, 'A Catalogue of the Paintings, Drawings and Pastels of Sir Thomas Lawrence', *Walpole Society*, 39 (1964), pp. 246–7.

23 *Bath Entertain'd*, p. 59; *Bath Chronicle*, 5 April 1792, p. 3.

24 I am grateful to Susan Sloman for sharing her draft catalogue of Lawrence's pre-1788 graphite drawings, which expands on Garlick 1964.

25 Williams, vol. I, p. 40.

26 *Bath Chronicle*, 4 May 1780, p. 2.

27 *Bath Chronicle*, 22 June 1780, p. 2.

28 *Oxford Journal*, 13 November 1779, p. 3. I am grateful to Susan Sloman for correcting Garlick's erroneous reference.

29 Bernard, vol. 2, p. 81.

30 Williams, vol. 1, p. 68; George Somes Layard, *Sir Thomas Lawrence's Letter-Bag*. London: George Allen, 1906, pp. 2–3.

31 Algernon Graves, *The Royal Academy of Arts: A Complete Dictionary of its Contributors*, 8 vols. London: Henry Graves and George Bell, 1906, vol. IV, p. 113.

32 Williams, vol. 1, p. 68.

33 Daines Barrington, *Miscellanies*. London: J. Nichols, 1781, p. 317.

34 *Bath Chronicle*, 30 November 1780, p. 3.

35 Ibid.

36 Michael Forsyth, *Pevsner Architectural Guides: Bath*. New Haven, CT, and London: Yale University Press, 2003, pp. 29, 250.

37 *Bath Chronicle*, 15 June 1780, p. 3.

38 *Bath Chronicle*, 5 January 1786, p. 1; 5 September 1799, p. 3.

39 Trevor Fawcett, *Georgian Imprints*. Bath: Ruton, 2008, pp. 40–1.

40 Judy Egerton, *Wright of Derby*. London: Tate Gallery, 1990, p. 247; Amina Wright, *Joseph Wright of Derby: Bath and Beyond*. London: Philip Wilson Publishers, 2014, p. 43.

41 Susan Sloman and others, *Pickpocketing the Rich*. Bath: Holburne Museum of Art, 2002, p. 82.

42 Lady Frances Harpur to Thomas Lawrence, 6 December 1780, Royal Academy of Arts Archive LAW/1/5; Layard, p. 2.

43 Williams, vol. 1, p. 80.

44 Hugh Belsey, 'A Visit to the Studios of Gainsborough and Hoare', *The Burlington Magazine* 129.1007 (February 1987), pp. 107–9, p. 108.

45 Layard, p. 249.

46 Robyn Asleson, ed., *A Passion for Performance: Sarah Siddons and her Portraitists*. Los Angeles: Getty Trust, 2001, p. 59.

47 Thomas Campbell, *Life of Mrs. Siddons*. London: Edward Moxon, 1839, p.131.

48 Williams, vol. 1, p. 385.

49 *Bath Chronicle*, 6 May 1784, p. 3; 13 May 1784, p. 3.

50 Williams, vol. 1, p. 16.

51 Williams, vol. 1, p. 221.

52 Williams, vol. 1, pp. 61–2; Barrington, p. 317.

53 Williams, vol. 1, pp. 70–1; John Hayes, *The Letters of Thomas Gainsborough*. New Haven, CT: Yale University Press, 2001, p. 123.

54 Vatican Museums, Rome.

55 Levey, n. 22, p. 323. The Bowdlers of Ashley, near Box, had a town house at 4 Alfred Street (Attested copy will and codicil of Thomas Bowdler, 19 March 1784, Bath Record Office Deeds 0429/1/2).

56 Williams, vol. 1, pp. 88–90.

57 Letter to Sir Charles Eastlake, 12 February 1822, RA Archive LAW/4/2; Layard, pp. 169–70.

58 Ibid.

59 Letter to Thomas Falconer, 10 September 1785, transcribed in Levey, pp. 62–3.

60 Williams, vol. 1, p. 84.

61 Ellen Wilson, 'A Shropshire Lady in Bath, 1794–1807', *Bath History*, 4 (1992), 95–123, p. 100, 105; D. Falconer and G. Falconer, *Dr William Falconer's early patronage of Sir Thomas Lawrence PRA*. Bath, 1981; Williams, vol. 1, pp. 84–5.

62 Richard Warner, *Literary Recollections*. London: Longman, 1830, vol. 2, p. 256.

63 Sophia Lee, *A Hermit's Tale: Recorded by his own Hand, and Found in his Cell*. London: T. Cadell, 1787.

64 Steven Gores: 'The Lees and the Sheridans: An Unexamined Connection', in Jack E. DeRochi and Daniel James Ennis, *Richard Brinsley Sheridan: The Impresario in Political and Cultural Context*. Lewisburg: Bucknell University Press, 2013, pp. 161–76.

65 Trevor Fawcett, 'Private Schooling in Eighteenth-century Bath', *Bath History*, 12 (2011), 63–79, pp. 71–3.

66 *Bath Entertain'd*, p. 25. Italics in the original.

67 Samuel Jackson Pratt, *Landscapes in Verse Taken in Spring by the Author of Sympathy*. London, 1785, p. vii.

68 Williams, vol. 1, pp. 68–9; Virginia Blain, Patricia Clements and Isobel Grundy, *The Feminist Companion to Literature in English*. London: Batsford, 1990, p. 13.

69 Rebecca Warner, *Original Letters*. London: Longman and Bath: Cruttwell, 1817, p. 232. I am grateful to James Baxendale for sharing his research on Mary Hartley and her drawings.

70 Kim Sloan, 'A Noble Art'. London: British Museum, 2000, cat. no. 112; letter to Mary Hartley, 6 April 1787, transcribed in Goldring, pp. 63–5.

71 Levey, p. 49; Letter to Mary Hartley, 26 June 1787, quoted in Richard Warner, vol. 2, pp. 472–5.

72 Jacob Simon, 'Lawrence's approach to Picture Framing' in Thomas Lawrence and Picture Framing. London: National Portrait Gallery, 2010 at https://www.npg.org.uk/research/programmes/the-art-of-the-picture-frame/thomas-lawrence-and-picture-framing/.

73 Samuel's portrait is dated 4 March 1786.

74 Richard Cumberland, *Memoirs of Richard Cumberland written by himself*. London: Lackington, Allen & Co., 1806, pp. 122–3.

75 Clementina Black, *The Linleys of Bath*, London: Martin Secker, 1911, pp. 153–4, 254.

76 Dulwich Picture Gallery, London.

77 Thomas Lawrence to Anne Lawrence, 1780s, RA Archive GAR/1/67.

78 Collection of the Duke of Beaufort, Badminton; Levey, p. 55; Garlick 1964, p. 266.

79 *Gentleman's Magazine*, vol. 38, August 1852, p. 202; *Bath Chronicle*, 25 December 1783, p. 3; 11 March 1784, p. 3.

80 Levey, p. 59.

81 John Steegmann, 'William Williams of Norwich', *The Burlington Magazine*, 75.436 (July 1939), pp. 22–7, 27.

82 Levey, p. 63; *Bath Entertain'd*, p. 78.

83 Bernard, pp. 86–9.

84 Undated letter to Lucy Lawrence, September 1786 or 1787. RA Archive LAW/1/14; Layard, pp. 7–8.

85 Allan Cunningham, *The Lives of the Most Eminent British Painters, Sculptors and Architects*. London: John Murray, 1833, vol. 6, p. 167.

86 Graves, vol. 5, p. 1.

87 Goldring, pp. 63–5.

88 Letter to Mary Hartley, 23 April 1787, transcribed in Goldring, p. 65.

89 Layard, p. 7.

90 Marcia Pointon, 'Portrait Painting as a Business Enterprise in London in the 1780s', *Art History*, 7.2 (June 1984), 187–205, p. 185, p. 190.

91 Williams, vol. 1, p. 98.

92 Victoria Art Gallery, Bath and Sotheby's, London, 6 July 2011 (47).

93 Goldring, p. 68.

94 Cunningham, pp. 194–5.

95 Layard, p. 15.

96 A. Cassandra Albinson, 'The Hidden Stratum of the Sketch: Thomas Lawrence and the Geology of English Portraiture', in Peter Wagner et al., *The Ruin and the Sketch in the Eighteenth Century*, Trier: Wissenschaftlicher Verlag Trier, 2008, 197–209, p. 198; Williams, vol. 2, p. 483.

97 Letter to Mary Hartley, 2 January 1788, quoted in Richard Warner, vol. 2, p. 475.

98 Williams, vol. 1, p. 99.

99 Williams, vol. 1, pp. 110–11.

100 John Ingamells, *National Portrait Gallery: Mid-Georgian Portraits 1760–1790*. London: National Portrait Gallery, 2004.

101 Burney, pp. 316–17.

102 *The World*, 16 April 1790, p. 3.

103 J. R. Harris, *The Copper King: A Biography of Thomas Williams of Llanidan*. Liverpool: Liverpool University Press, 1964.

104 Williams, p. 71.

105 Montagu Pennington: *Memoirs of the Life of Mrs.*

Elizabeth Carter. London: F.C. and J. Rivington, 1807, pp. 320–1.

106 Kenneth Garlick, *Sir Thomas Lawrence*. Oxford: Phaidon, 1989, p. 274.

107 Ibid., p. 248.

108 Letter from H. Compton to Thomas Lawrence, [September 1789] RA Archive LAW/1/18; Layard, p. 10.

109 Mrs Vernon Delves Broughton, *Court and Private Life in the Time of Queen Charlotte*. London: R. Bentley, 1887, vol. 2, p. 134.

110 Ibid., p. 133.

111 Ibid., pp. 141–2.

112 Levey, n. 50, p. 325.

113 *The World*, 29 April 1790.

114 *The World*, 1 May 1790; Edward Kite, 'Some New Lawrence Letters' in *The Connoisseur*, 56 (January to April 1920), 243–5, p. 243. Lawrence was probably born on 13 April 1769; he was baptised and celebrated his birthday on 4 May.

115 Kite, p. 244.

116 Ibid., p. 243.

117 Letter from Lucy Lawrence, Duke St., St. James, to Thomas Lawrence, 4 May 1790, RA Archive GAR/1/9.

118 Judy Egerton, *The British School*. London: National Gallery, 1998, p. 358.

119 *The World*, 4 May 1790.

120 *St James Chronicle*, 1–4 May 1790.

121 Layard, p. 23.

122 Joseph Farington, 16 January 1794 in James Greig, ed., *The Farington Diary*. London: Hutchinson & Co., 1928, vol. 1, p. 34.

123 Garlick 1989, pp. 294–5; Christie's, New York, 13 April 2016 (15).

124 Garlick, 'Two Lawrence Landscapes', *The Ashmolean*, 25 (Christmas 1992), 15–18.

125 Oliver Millar, *The Later Georgian Pictures in the Collection of Her Majesty the Queen*. London: Phaidon, 1969, text volume, p. 63.

126 Philip Kelley et al., 'New Light on Sir Thomas Lawrence's "Pinkie"' in Huntington Library Quarterly 28/3 (May 1965), 255–61, p. 257.

127 Williams, vol. 1, p. 103.

128 Layard, pp. 12–13.

129 John Locke, 'Some thoughts concerning education (1693)', in John W. Yolton, *The Clarendon Edition of The Works of John Locke*. Oxford: Clarendon Press, 1989, p. 152.

130 Marcia R Pointon, *Portrayal and The Search for Identity*. London: Reaktion Books, 2013, p. 78.

131 A. Cassandra Albinson: 'Debt and Drawing: Thomas Lawrence's Family Portraits at the Cantor Art Center', *Cantor Art Center Journal* (2013), pp. 50–63.

132 H. Diack Johnstone, 'Linley, William (1771–1835), Composer and Author', in *Oxford Dictionary of National Biography*. Oxford: Oxford University Press, 2008.

133 A. Cassandra Albinson, Peter Funnell and Lucy Peltz, *Thomas Lawrence: Regency Power & Brilliance*. New Haven, CT, and London: Yale University Press, 2010, p. 115.

134 Private Collection, see Albinson et al. 2010, pp. 143–5; National Portrait Gallery, see ibid., pp. 146–8; Yale Center for British Art, see ibid., pp. 155–7.

135 Charles Ryskamp, 'Lawrence's Portrait of Cowper', *Princeton University Library Chronicle* 20.3 (Spring 1959), 140–4, p. 140; Williams, vol. 1, pp. 162–3.

136 Marcia R. Pointon, *Milton and English Art*. Manchester: Manchester University Press, 1974, pp. 116–18.

137 John Milton, *Paradise Lost* 1:35.

138 Garlick 1964, p. 255.

139 *Paradise Lost*, 1:601.

140 Levey, p. 63.

141 *Paradise Lost* 1:330.

142 Anthony Pasquin [John Williams], *A Critical Guide to the Present Exhibition at the Royal Academy, for 1797*. London: 1797, p. 7.

143 Joseph Farington, 12 April 1797.

144 Martin Myrone, *Body Building: Reforming Masculinities in British Art 1750–1810*. New Haven, CT, and London: Yale University Press, 2005, p. 253.

145 Benjamin Robert Haydon, *Diary*, quoted in Albinson et al. 2010, p. 1.

146 Williams, vol. 2, pp. 42–3, Levey, p. 32.

147 Williams, vol. 1, pp. 184–5, p. 187.

148 Ibid., p. 186.

149 Sarah Siddons to Penelope Pennington, August 1798, in Oswald Knapp, *An Artist's Love Story*. London: George Allen 1904, p. 74.

150 Joseph Farington, 18 March 1801, in Greig vol. 1, p. 304.

151 Benjamin Robert Haydon, quoted in Kenneth Garlick, 'Notes on Sir Thomas Lawrence', *The Burlington Magazine*, 93/581 (August 1951), 249–54, p. 250.

152 Layard, p. 2.

153 Williams, vol. 2, pp. 188–9.

154 Williams, vol. 2, p. 159; Michael Levey, 'Lawrence's Portrait of Pope Pius VII', *The Burlington Magazine*, 117/865 (April 1975), 194–204, p. 202.

155 Layard, p. 169.

Select Bibliography

Albinson, A. Cassandra, 'The Hidden Stratum of the Sketch: Thomas Lawrence and the Geology of English Portraiture' in Peter Wagner et al., *The Ruin and the Sketch in the Eighteenth Century*. Trier, Wissenschaftlicher Verlag Trier, 2008, pp. 197–209.

Albinson, A. Cassandra, 'Debt and Drawing: Thomas Lawrence's Family Portraits at the Cantor Art Center', *Cantor Art Center Journal* (2013): 50–63.

Albinson, A. Cassandra, Funnell, Peter and Peltz, Lucy, *Thomas Lawrence: Regency Power & Brilliance*. New Haven, CT, and London, Yale University Press, 2010.

Asleson, Robyn, ed., *A Passion for Performance: Sarah Siddons and her Portraitists*. Los Angeles, Getty Trust, 2001.

Ayres, James, *Art, Artisans and Apprentices: Apprentice Painters and Sculptors in the Early Modern British Tradition*. Oxford and Philadelphia, Oxbow Books, 2014.

Bernard, John, *Retrospections of The Stage*, 2 vols, London, Colburn and Bentley, 1830.

Black, Clementina, *The Linleys of Bath*. London, Martin Secker, 1911.

Clarke, Michael and Penny, Nicholas, eds, *The Arrogant Connoisseur: Richard Payne Knight 1751–1824*. Manchester, Manchester University Press, 1982.

Colville, Quintin, and Williams, Kate, *Emma Hamilton: Seduction and Celebrity*. London, Thames and Hudson, 2016.

Cunningham, Allan, *The Lives of the Most Eminent British Painters, Sculptors and Architects*, 6 vols. London, John Murray, 1833.

Eger, Elizabeth and Peltz, Lucy, eds, *Brilliant Women: 18th-Century Bluestockings*. London, National Portrait Gallery, 2008.

Egerton, Judy, *The British School*. London, National Gallery, 1998.

Fawcett, Trevor, *Bath Entertain'd*. Bath, Ruton, 1998.

Fletcher, Anthony, *Growing Up in England*. New Haven, CT, and London, Yale University Press, 2010.

Garlick, Kenneth, 'Notes on Sir Thomas Lawrence', *The Burlington Magazine* 93/581 (August 1951): 249–54.

Garlick, Kenneth, 'A Catalogue of the Paintings, Drawings and Pastels of Sir Thomas Lawrence', *Walpole Society*, 39 (1964).

Garlick, Kenneth, *Sir Thomas Lawrence*. Oxford, Phaidon, 1989.

Goldring, Douglas, *Regency Portrait Painter: The Life of Sir Thomas Lawrence, PRA*. London, Macdonald, 1951.

Ingamells, John, *National Portrait Gallery: Mid-Georgian Portraits 1760–1790*. London, National Portrait Gallery, 2004.

Jeffares, Neil, *Dictionary of Pastellists Before 1800*. London, Unicorn Press, 2006.

Kite, Edward, 'Some New Lawrence Letters', *The Connoisseur*, 56 (January to April 1920): 243–45.

Layard, George Somes, *Sir Thomas Lawrence's Letter-Bag*. London, George Allen, 1906.

Levey, Michael, *A Royal Subject: Portraits of Queen Charlotte*. London, National Gallery, 1977.

Levey, Michael, *Sir Thomas Lawrence*. London, National Portrait Gallery, 1979.

Levey, Michael, *Sir Thomas Lawrence*. New Haven & London, Yale University Press, 2005.

Lloyd, Stephen, and Sloan, Kim, *The Intimate Portrait: Drawings, Miniatures and Pastels from Ramsay to Lawrence*. Edinburgh, National Galleries of Scotland, 2008.

Looser, Devoney, 'The Blues Gone Grey: Portraits of Bluestocking Women in Old Age', in *Bluestockings Displayed: Portraiture, Performance and Patronage, 1730–1830*. Cambridge, Cambridge University Press, 2013, pp. 100–20.

McPherson, Heather, *Art and Celebrity in The Age of Reynolds and Siddons*. University Park, Philadelphia, Penn State University Press, 2017.

Myrone, Martin, *Body Building: Reforming Masculinities in British Art 1750–1810*. New Haven, CT, and London, Yale University Press, 2005.

Newby, Evelyn, 'The Hoares of Bath', *Bath History* 1 (1988): 90–127.

Perry, Gill, and Rossington, Michael, *Femininity and Masculinity in Eighteenth-Century Art and Culture*. Manchester, Manchester University, 1993.

Pointon, Marcia, 'Portrait Painting as a Business Enterprise in London in the 1780s', *Art History*, 7.2 (June 1984): 187–205.

Pointon, Marcia R., *Portrayal and The Search for Identity*. London, Reaktion Books, 2013.

Postle, Martin, *Angels & Urchins: The Fancy Picture in 18th-Century British Art*. London, Lund Humphries, 1998.

Simon, Robin and Stevens, Maryanne, eds, *The Royal Academy of Arts: History and Collections*. New Haven, CT, and London, Yale University Press, 2018.

Sloman, Susan Legouix, 'Artists' Picture-rooms in Eighteenth-Century Bath', *Bath History*, 6 (1996): 133–54.

Sloman, Susan, *Gainsborough in Bath*. New Haven, CT, and London, Yale University Press, 2002.

Sloman, Susan, Fawcett, Trevor, et al., *Pickpocketing the Rich*. Bath, Holburne Museum of Art, 2002.

Smith, T.B., 'On the Early Life of Sir Thomas Lawrence, PRA', *Wiltshire Archaeological and Natural History Society Magazine*, IX (1866), 194–205.

Solkin, David H., ed., *Art on The Line: The Royal Academy Exhibitions at Somerset House 1780–1836*. New Haven, CT, and London, Yale University Press, 2002.

Steward, James Christen, *The New Child: British Art and the Origins of Modern Childhood 1730–1830*. Berkeley, University of California, 1995.

Waterfield, Giles and Kalinsky, Nicola, *Leaving Portraits from Eton College*. London, Dulwich Picture Gallery, 1991.

Williams, D.E., *Life and Correspondence of Sir Thomas Lawrence*, 2 vols. London, Henry Colburn and Richard Bentley, 1831.

Wright, Amina, *Joseph Wright of Derby: Bath and Beyond*. London, Philip Wilson Publishers, 2014.

Image Credits

1 Victoria Art Gallery, Bath and North East Somerset Council / Bridgeman Images

2, 8, 9, 11, 23, 39 © The Trustees of the British Museum

3 Iris & B. Gerald Cantor Center for Visual Arts at Stanford University; Alice Meyer Buck Fund

4 Courtesy of the Garrick Club, London

5, 14, 17, 18, 42 © The Holburne Museum

6 © The Devonshire Collections, Chatsworth. Reproduced by permission of Chatsworth Settlement Trustees

7 Yale Center for British Art, Paul Mellon Collection

10 © National Trust Images / John Hammond

12 © The Fitzwilliam Museum, Cambridge

13 Yale Center for British Art, Paul Mellon Fund

15 Photo courtesy of John Mitchell Fine Paintings, London

16 Philadelphia Museum of Art, Purchased with the SmithKline Beckman Corporation Fund

19 © The National Gallery, London

20 By kind permission of the owner

21 Patrick Bourne & Co.

22 Yale Center for British Art, Gift of Diane Nixon in honour of Lowell Libson

24, 28, 44 © National Portrait Gallery, London

25 © Victoria and Albert Museum, London

26 © Amgueddfa Genedlaethol Cymru; © National Museum of Wales

27, 33 © Tate, London 2020

29 National Trust for Scotland, Fyvie Castle

30 Photograph © 2020 Museum of Fine Arts, Boston

31, 37 © Christie's Images / Bridgeman Images

32 © The Whitworth, The University of Manchester / Bridgeman Images

34 Bridgeman Images

35 Courtesy of the Huntington Art Collections, San Marino, California

36, 51 Royal Collection Trust / © Her Majesty Queen Elizabeth II 2020

38 © Bryan F. Rutledge B.A. © Duke of Abercorn

40 The Metropolitan Museum of Art

41 Dulwich Picture Gallery, London

43 Los Angeles County Museum of Art

45 Courtesy of Bagshawe Fine Art

46 © Royal Academy of Arts, London. Photographer: Marcus Leith

47 © Royal Academy of Arts, London

48 © Royal Academy of Arts, London. Photographer: Prudence Cuming Associates Limited

49 © Royal Academy of Arts, London. Photographer: John Hammond

50 Private Collection, UK c/o Lowell Libson & Jonny Yarker Ltd.

Every effort has been made to secure all necessary permissions to reproduce images within this book. Any errors or omissions should be addressed to the Holburne Museum.

Index

Page numbers in **bold** refer to illustrations. All works of art are by Thomas Lawrence unless otherwise stated.